Postcard History Series

Rochester

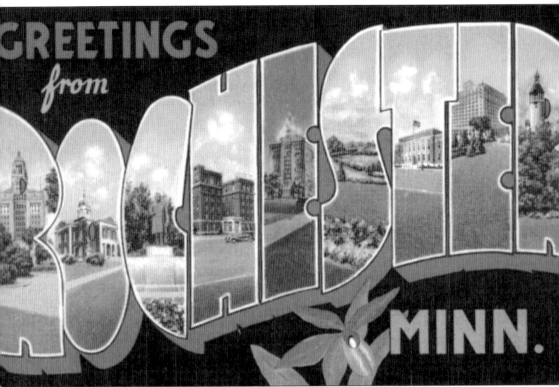

This is one of literally thousands of "big letter" postcards produced by the Curt Teich postcard company for towns and cities throughout the United States. There were three different versions produced for Rochester alone. Each letter of the city's name illustrates a location of local interest. In this case, the letters depict, from left to right, the Plummer Building, the 1958 Olmsted County Court House, the Mayo Park statue of William W. Mayo, the Colonial Hospital, another image of the Plummer Building, Mayo Park, the 1932 Rochester City Hall, the Kahler Hotel, and the water tower at the Plummer House.

On the front cover: This postcard shows First Avenue SW (looking north) as it existed in about 1930. Nearly all the buildings on the west side of First Avenue SW have been replaced or demolished, some as recently as 2007. In the lower right-hand corner of the card, just a tiny slice of the 1884 Rochester City Hall can be seen. (Author's collection.)

On the back cover: Before electrical refrigeration, frozen lakes and rivers were the main source for ice. In this postcard, the men are harvesting ice blocks in the Zumbro River. Once the ice was harvested, it was packed in sawdust and saved for use throughout the year. It was also shipped via railroad to southern states that did not experience freezing temperatures. (Courtesy of Dick and Nancy Trusty.)

Postcard History Series

Rochester

Alan Calavano

Copyright © 2008 by Alan Calavano
ISBN 978-0-7385-5194-4

Published by Arcadia Publishing
Charleston SC, Chicago IL, Portsmouth NH, San Francisco CA

Printed in the United States of America

Library of Congress Catalog Card Number: 2007940138

For all general information contact Arcadia Publishing at:
Telephone 843-853-2070
Fax 843-853-0044
E-mail sales@arcadiapublishing.com
For customer service and orders:
Toll-Free 1-888-313-2665

Visit us on the Internet at www.arcadiapublishing.com

This book is dedicated to my parents, Anthony Michael Calavano and Viola Anna Stier, and to the History Center of Olmsted County.

Contents

Acknowledgments 6

Introduction 7

1. Aerial Views and Street Scenes 9

2. Hotels, Motels, and Cabins 23

3. Restaurants 47

4. Churches and Religious Institutions 59

5. Medical Complex 71

6. Homes 79

7. Public Facilities 87

8. Businesses 105

Acknowledgments

This book would not have been possible without the help of many people. First of all, I would like to thank the photographers who captured the images used to create the postcards, including Carl Holland, Eugene Cutshall, Bert Crowell, Clarence Stearns, S. H. Olson, and the many others who were not documented.

I would also like to thank the postcard companies that purchased these images and produced the postcards we now collect, including the Co-Mo Company in Minneapolis, E. C. Kropp Company in Milwaukee, the L. L. Cook Company in Milwaukee, Curt Teich in Chicago, Bloom Brothers Company in Minneapolis, and Dexter Press in West Nyack, New York.

Next I would like to thank the postcard dealers and friends who helped me compile my personal Rochester postcard collection, including John Cole of Kenyon, Jerry Andreen of Rockville, Illinois, Audrey Annis of Mapleton, Richard and Kay Townsend of Rochester, John Kruesel of Rochester, and Ann and Randy Collins of Rochester.

I would particularly like to thank the other Rochester postcard collectors and friends who care enough about Rochester's history to locate and preserve its postcards and who graciously gave me access to their collections, specifically the History Center of Olmsted County and its executive director, John Hunziker; Peter McConahey; Dr. Paul Scanlon; Dick and Nancy Trusty; Mike and Denette Szuberski; Dr. and Mrs. Brian Dawson; Candace Williams; Kevin and Cindy Reynolds; Roy Sutherland; and Dennis Peterson.

Lastly and perhaps most of all, I would like to thank the people who helped locate the research materials I used to identify and describe the postcards and who have always had the patience to help answer my many, many (often dumb) questions about Rochester's history, including Sherry Sweetman, archivist at the History Center of Olmsted County; Marilyn Hensley, History Center of Olmsted County librarian; Ken Allsen, author of *Houses on the Hill*; Barby Withers, granddaughter of Gertrude Mayo Berkman and niece of Daisy Berkman Plummer; and Mary Jane Schmitt, board member and volunteer extraordinaire at the History Center of Olmsted County.

Introduction

In 1854, George Head and wife, Henrietta, moved to Olmsted County and gave Rochester its name based on the fact that the Zumbro River reminded them of the Genesee River in their hometown of Rochester, New York. Legend has it that the Heads marked the path of Broadway by dragging a log behind a team of oxen.

In 1858, Minnesota became a state and Rochester was incorporated as a city. Rochester had been designated county seat of Olmsted County in 1856.

In 1863, Dr. William W. Mayo moved to Rochester from Le Sueur with his wife and family to serve as the Civil War examining surgeon, a position to which he had been appointed by Pres. Abraham Lincoln.

In 1877, the Sisters of St. Francis of Our Lady of Lourdes, a teaching order, formed a new community in Rochester under Mother Mary Alfred Moes.

In 1879, the Second Minnesota Hospital for the Insane opened in Rochester and remained open until 1982. In 1984, the state hospital property became the Federal Medical Center.

In 1883, a severe tornado killed 26 people and destroyed many Rochester buildings. Mayo asked Moes and the Sisters of St. Francis to help care for the wounded at their convent. Inspired by this natural disaster, Moes raised money to build St. Marys Hospital, which opened in 1889. Mayo and his two sons, William J. and Charles H., comprised the initial medical staff for the hospital.

In 1914, the original Mayo Clinic building opened. In 1923, the Mayo doctors completed a reorganization in which all clinic assets were transferred to the Mayo Properties Association (Mayo Foundation), a nonprofit corporation.

In 1915, a two-year college called Southern University opened in the Rochester High School building (later renamed the Coffman Building). In 1917, the college was renamed Rochester Junior College. In 1968, the junior college moved to its current campus in southeast Rochester, and in 1973, the school was renamed Rochester Community College. In 1996, the community college merged with the technical college and became the Rochester Community and Technical College (RCTC).

In 1928, the second Mayo Clinic building opened. It was later renamed the Plummer Building in honor of Dr. Henry S. Plummer, who designed many of the building's operational features.

In 1930, the Central Fire Station was removed from the center of Broadway Avenue South, and Broadway was extended south to cross the Zumbro River.

In 1939, the Mayo Civic Auditorium opened. It was donated to the people of Rochester by Dr. Charles H. Mayo and the Mayo Foundation.

In 1950, the Central School building was torn down to make room for the new Mayo Building. From 1966 until 1970, the Mayo Building was raised to 20 stories. Also in 1958, John Marshall High School opened. Mayo High School opened in 1966. Century High School opened in 1997.

In 1952, the Miracle Mile Shopping Center opened as the first Minnesota shopping center outside the Twin Cities. In 1971, a fire destroyed much of the south end of the center. In 1969, the Apache Mall opened.

In 1956, IBM announced plans to locate in Rochester.

In 1978, a major Rochester flood caused $60 million in damages. Previous major floods occurred in 1908 and 1951 with lesser floods in 1859, 1866, 1882, 1925, 1962, and 1965. In 1995, the $155 million flood control project was dedicated.

In 1993, the new Government Center opened.

In 2001, the Mayo Gonda Building opened.

On January 1, 2008, Rochester annexed a swath of land along Marion Road, and its population shot past 100,000 people, making it officially a "City of the First Class."

In 1918, the names of nearly all Rochester roads were changed from names like Oak, College, Zumbro, and Flathers, to numbered roads, that is, First, Second, Third, and Fourth, with streets running from east to west and avenues running from north to south. A quadrant system was also adopted in which Broadway divided the city east and west and Center Street divided the city north and south. The History Center of Olmsted County can provide a complete list of the old and new names.

For the purposes of this book, the following few changes might prove helpful: Zumbro Street became Second Street South, College Street became Fourth Street South, Broadway remained Broadway, Main Street became First Avenue West, Fifth Street became Center Street, and Third Street became Third Street South.

All the images in this book are vintage Rochester postcards.

The golden age of picture postcards in the United States started in about 1905 and continued until about 1915. Prior to the 1893 World's Columbian Exposition, the few postcards that existed were primarily textual postcards often containing invoices or short printed messages.

Postcard collecting (officially called deltiology) is one of the fastest-growing hobbies in the United States. There are nearly as many different reasons for collecting postcards as there are people collecting them. For starters, many postcards are relatively inexpensive, they do not take up much space, and there are literally thousands of different categories of postcards that one can collect, including postcards of places (called views) to topical postcards of animals, advertising, flowers, or world's fairs.

For additional information about postcard collecting, please contact the author or visit the following Web sites: www.twincitypostcardclub.com, the Web site of the Twin City Postcard Club, which meets monthly in the Minneapolis–St. Paul metropolitan area and hosts two postcard shows each year; www.postcard.org, the Web site of the San Francisco Bay Area Post Card Club, which contains pointers to many valuable postcard reference resources in its links area; www.teicharchives.org, the Web site of the Curt Teich Postcard Archives; www.postcardcollector.com, the Web site of the *Postcard Collector* monthly magazine; and www.barrspcn.com, the Web site of *Barr's Postcard News* semimonthly newspaper.

One

AERIAL VIEWS AND STREET SCENES

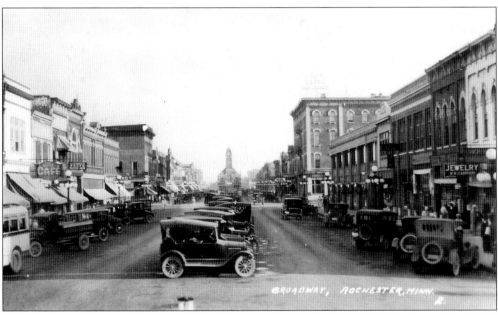

This vintage street scene from the 1920s shows Broadway looking south. The Central Fire Station was in the middle of Broadway South, but since there was no bridge on Broadway over the Zumbro River at the time, this did not present a problem. The large building on the right about halfway back is the Cook Hotel, and Knowlton's Department Store is the two-story building just before it (across Second Street SW). One good thing about Broadway being so broad was that it permitted both diagonal and center-of-the-street parking.

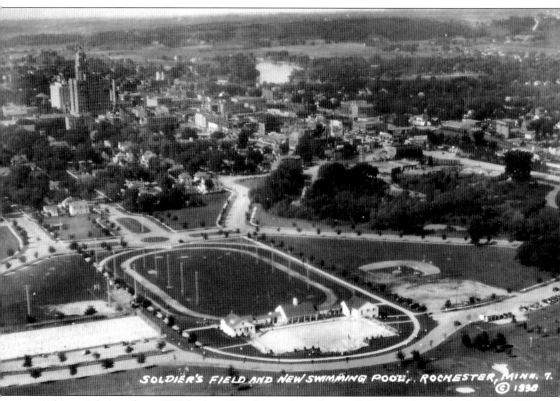

This aerial view from 1938 looks at Rochester from the south in a northeasterly direction. The Plummer Building was built in 1928, but the Mayo Building was not constructed until after 1958. In the foreground is Soldiers Memorial Field and the (then) new swimming pool. Soldiers Memorial Field was created in the early 1920s when the American Legion Post 92 approached Dr. Christopher Graham about buying or leasing a 160-acre marshy area of his property formerly known as Van Dusen's Pasture. Its intent was to develop a golf course on part of the land and eventually an entire recreation area, all of it as a memorial to fallen comrades. Graham agreed to sell the land for $33,000 with a down payment of only $3,000, and after much work, the golf course opened on May 8, 1927. That same year, the American Legion turned the land over to the city. In 1929, Dr. E. Starr Judd gave to the city the field house (designed by Harold Crawford), which provided facilities for high school teams and later served as part of the pool bathhouse. The original swimming pool (shown in the postcard) was built in 1936. The pool was a WPA project and was the first swimming pool in Rochester and the largest in the state. The pool was replaced in 1988. For 30 years, from 1929 until 1958 (when John Marshall High School and Stadium were constructed), the Rochester High School football team (the Rockets) played home football games at Soldiers Memorial Field. In 1953, plans were announced to build the new Rochester High School in Soldiers Memorial Field, but Mayor Claude McQuillan vetoed the sale of the parkland to the school district, and the new school was built where John Marshall now stands in northwest Rochester.

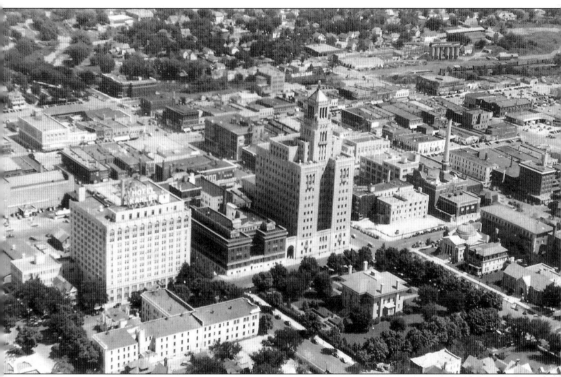

This aerial view from 1939 shows Rochester looking from the northwest in a southeasterly direction. The 1914 Clinic Building is clearly visible between the Kahler Hotel and the Plummer Building. The Kahler Hotel in this image only occupies about one-third of the block that it currently fills. The four-story Cook Hotel, seen just above the Plummer Building and slightly to the left, burned in 1947. The Hotel Norton in the upper left (directly above the Kahler) burned in 1967. The Olds Fishback Mill is also seen above the Plummer Building about a block south (right) of the Hotel Norton.

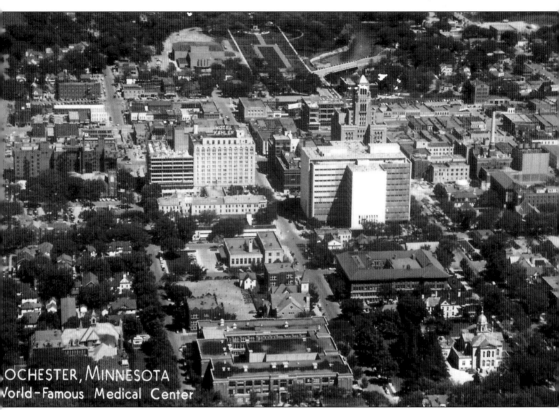

This aerial view looking east in about 1953 shows the 1866 Olmsted County Court House in the right foreground and its relationship to Coffman High School on Second Street SW. The first section of the Mayo Building has been completed (it was raised to 20 stories in 1969), and above the Plummer Building, one can see the new Dayton's building being constructed. Knowlton's was demolished in 1952, and Dayton's opened in 1954. One can also see the second section of the Kahler Hotel being constructed to the north of the first section. Above the new Dayton's, one can see the Mayo Memorial promenade where the Mayo Civic Center Arena and Rochester Art Center were subsequently built.

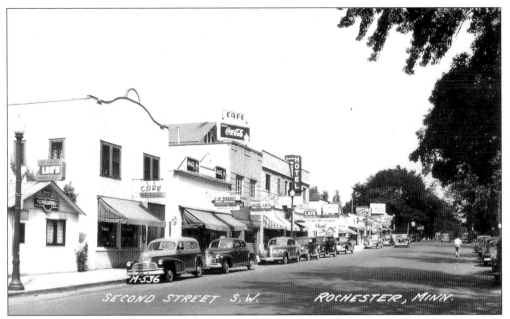

This real-photo postcard street scene from the early 1950s shows Second Street SW looking east. This area directly across the street from St. Marys Hospital has experienced tremendous change over the years, from a primarily residential neighborhood to an ever-growing collection of cafés, restaurants, and hotels. Even this image from 50 years ago shows the preponderance of businesses catering to St. Marys patients and staff.

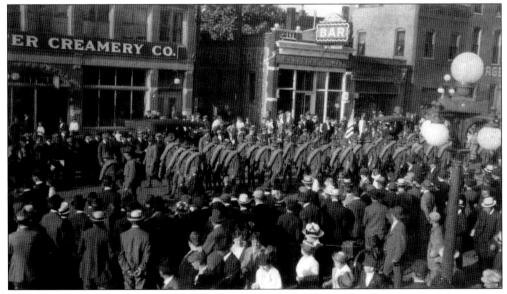

This postcard from 1916 or 1917 shows a World War I military detachment marching east on what is now Second Street SE. A portion of Hargesheimer's Drug Store at 202 Broadway South is visible in the upper right behind the streetlight. The Marquette Bar, located in the center of the image, was owned by G. F. Miller in 1917 at 12 East Zumbro Street (Second Street SE). The Rochester Creamery Company is on the left.

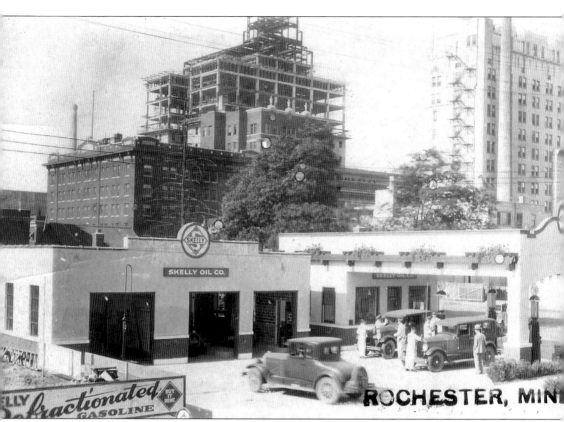

This great old real-photo postcard of Center Street near Broadway looking southwest is not dated, but judging by the Plummer Building's state of construction, it is likely from 1927. The Kahler Hotel is in the upper right, with the Hotel Zumbro and 1914 Clinic Building in the center (in front of the Plummer Building), and just a thin slice of the back of the Chateau Theatre is visible at the extreme left. This Skelly Oil service station, which was destroyed by fire in 1948, was the second service station to occupy this site; the first was a Home Oil Company station. This site is currently occupied by the Michaels Restaurant parking lot and the Center Street Parking Ramp.

This real-photo postcard street scene from about 1950 shows First Street SW at First Avenue SW looking west. The first section of the new Kahler Hotel (sometimes referred to as the Kahler Grand Hotel) was constructed on the southwest third of the block in 1921. It housed a 220-bed hotel, a 210-bed hospital, and a 150-bed convalescent home, plus three operating rooms and several laboratories. Notice the Wagoner Hotel in front of the Kahler and Whiting's Flowers. In 1954, the Kahler was expanded north to Center Street with the addition of another 257 rooms, but it still only occupied the west half of the block. In 1969, Kahler East, an 11-story, 161-room, multimillion-dollar addition was completed with an enclosed rooftop swimming pool. Still later, the Greenhouse Restaurant was added to Kahler East, and the all-new Penthouse Restaurant and Lounge replaced the 20-year-old Pinnacle Restaurant on the roof.

This real-photo postcard street scene from the early 1950s shows First Avenue SW looking south from Center Street. The Botsford Lumber Yard building was razed in 1953. The Hotel Zumbro is clearly visible in the center of the image with the Wagoner Hotel just in front of it. Also, just barely visible is the peaked roof of the Schuster Brewery building in the left rear of the image.

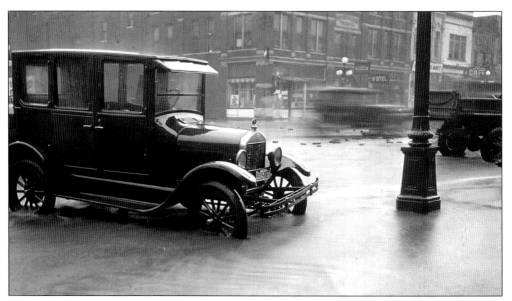

Rochester has a habit of getting its feet wet. Parked across the street from the Metropolitan Theater and Hotel, which was located on the southeast corner of Broadway and Center Street, this classy-looking vintage automobile is up to its front hubcaps in water. It keeps a wary headlight on the street's wooden pavers as they float by. Rochester's early streets were paved with these natural bricks that were actually blocks of wood.

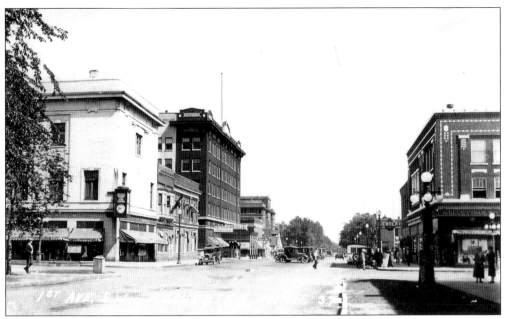

This real-photo postcard from the early 1930s shows First Avenue SW looking north from Second Street SW. The International Order of Odd Fellows (IOOF) Building on the right was renovated in 1934. On the left are the 1917 Rochester Masonic Temple, the Hotel Zumbro, and beyond that the Colonial Hospital. Of particular interest are the cars parked in the middle of the street.

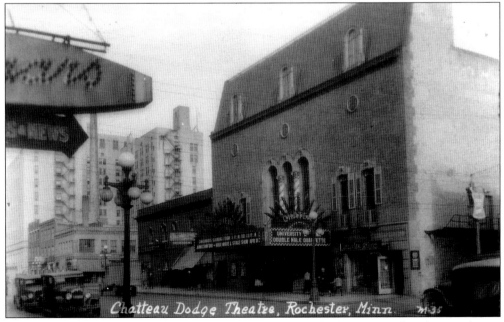

This wonderful old real-photo postcard shows First Street SW looking west. The Chateau Theatre was designed by Ellerbe Architects and completed in 1928. In 1994, the Chateau Theatre was completely renovated and resurrected as a beautiful Barnes and Noble bookstore, which is now incorporated into the Shops at University Square and the Rochester skyway system.

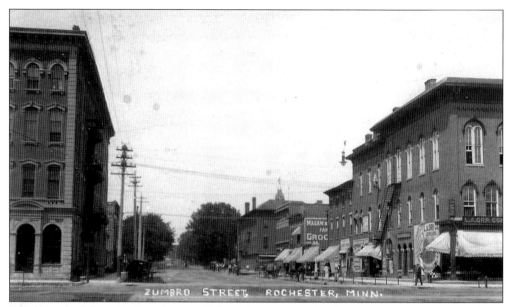

This image and the next three images all show the intersection of Second Street SW and Broadway looking west. In this 1909 image, the Cook Hotel is on the left and the Heaney Block is on the right. The Heaney Block was built in 1867 and destroyed by fire on January 11, 1917. The Cook Hotel was built in 1869 and largely destroyed by fire in 1947

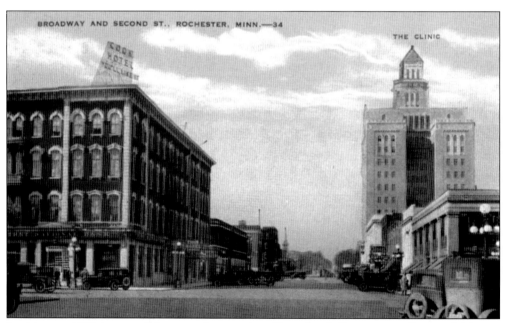

In this post-1928 image of the same intersection, Knowlton's Department Store, which was built in 1918, has replaced the Heaney Block. Although the postcard is not dated, it is post-1928 because it also contains the Plummer Building, which was completed in 1928.

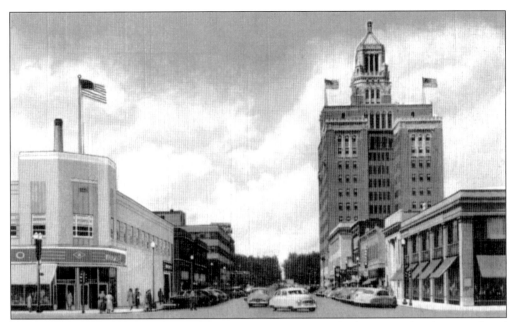

Seen here about 1950, the Cook Hotel, which was demolished in 1949, has been replaced by Woolworth's.

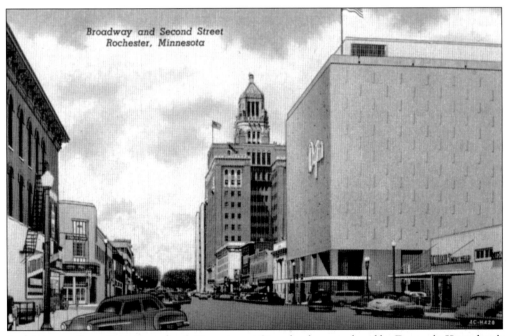

In this image from 1954, Knowlton's Department Store has been replaced by Dayton's. Knowlton's was demolished in 1952. The Dayton's store was specifically designed without windows because it was air-conditioned. In 1969, Dayton's moved to Apache Mall, and the Bell Telephone Company built a switching center in the building. The building now contains Mayo Clinic offices upstairs and a Red Lobster restaurant on the ground floor. The downtown Woolworth's store closed in 1994. Its building was later remodeled and is now known as the Lanmark Center.

The caption on the back of this three-part panoramic postcard from 1908 states, "Rochester, with a population of 8000 people, stands as one of the most progressive cities in the Union. Situated, as it is, in the midst of the most productive agricultural district in the world, it is a recognized centre of wealth and social prominence. As a city of homes, it is most excellence [sic], being blessed with an efficient public school system, numerous churches, public library, Y.M.C.A. building and other institutions which are so much desired in the training of the youthful mind.

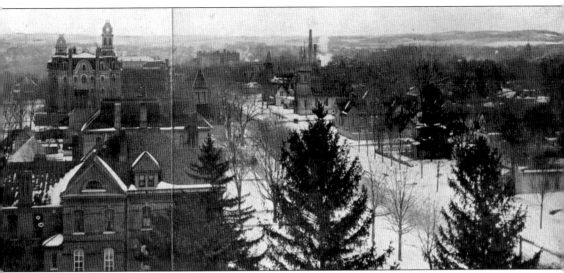

Here is also located St. Mary's Hospital, which has a world-wide reputation; the Minnesota State Hospital for Insane and the Academy of Our Lady of Lourdes." The Mayo Clinic is not mentioned in the caption because the Mayo Clinic, as it became known, did not exist in 1908. The term *Mayo Clinic* was not used until after the 1914 Clinic Building (sometimes called the Medical Block) was completed. In 1968, the spelling of St. Marys Hospital's name was officially changed to drop the apostrophe.

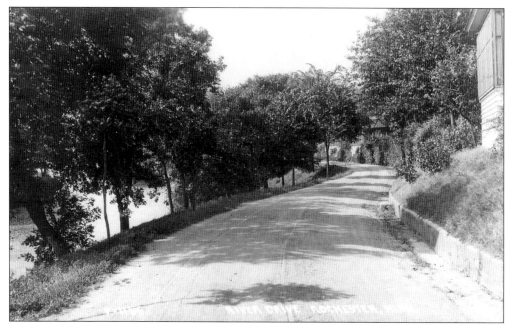

Mayo Park Drive SE is a one-lane street that runs for just a short distance south from Center Street to Third Street SE along the east bank of the Zumbro River (opposite the Mayo Civic Center).

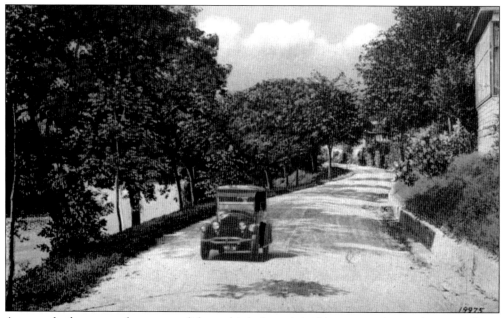

Apparently the postcard company did not think the original image was interesting enough, so it had an artist add the image of a car. Unfortunately, the artist did not realize that Mayo Park Drive is only about 12 feet wide, so the car he added is effectively only about 3 feet high when compared to the curb and the adjacent house.

Two

HOTELS, MOTELS, AND CABINS

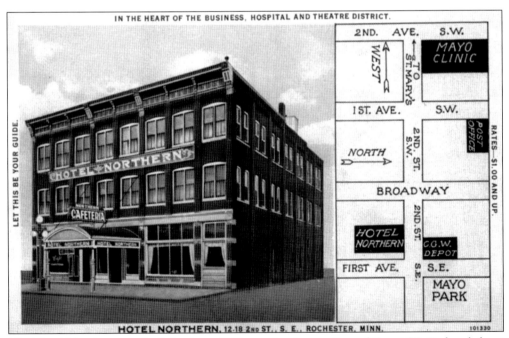

The Hotel Northern was built in about 1921 on what is now Second Street SE. It closed about 1947. This site now contains the Auto Park parking ramp, which was the first public parking ramp in Rochester, behind the Holiday Inn Downtown.

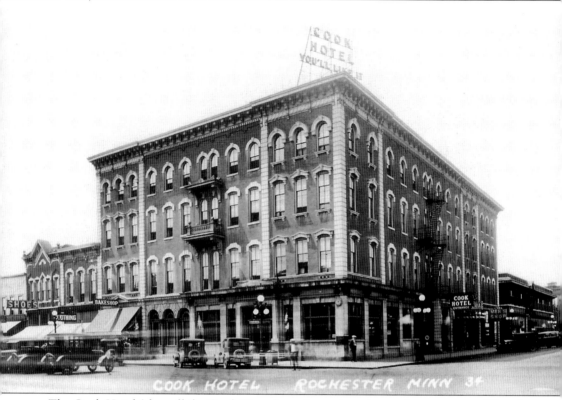

The Cook Hotel (also call the Cook House) was located on the southwest corner of Broadway and Second Street SW (originally called Zumbro Street). It was opened in 1869 by John Ramsey Cook, a 31-year-old native of Ohio who came to Rochester in 1856 with a fair-size fortune that he amassed from operating a store at Wolf Lake, Indiana, and from speculating in farmland. In 1864, Cook organized the First National Bank of Rochester. When the Cook Hotel opened, it was acclaimed as the finest hotel in southern Minnesota. Later it became somewhat of a white elephant, partially due to the depressed wheat market of the 1870s. John Kahler was brought to Rochester in 1887 to manage it, which he did successfully, later starting his own hotel. After a severe fire on February 3, 1947, the Cook Hotel building was reduced to two stories for several years. The building was demolished in 1949 to build a new Woolworth's store.

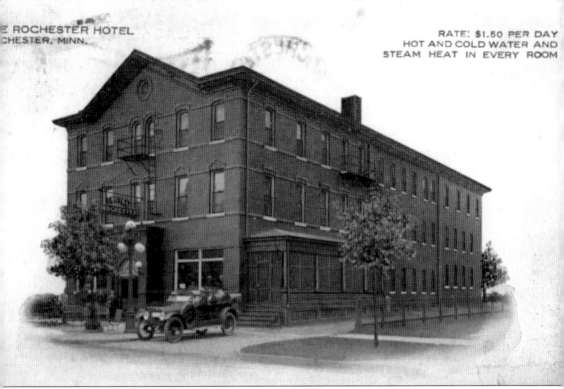

The Rochester Hotel at 217–219 First Avenue SW started life in 1877 as the Pierce House hotel. It was built by James Pierce and his wife, Sarah, on the site of the former Steven's House hotel, which burned down on September 3, 1877. The Pierce House was original constructed of wood and consisted of the front five-window section of the building. In 1880, the building received a brick facade. In March 1884, the name was changed to the Commercial House, but from February 1891 until March 1893, it was again the Pierce House. In March 1893, the name changed to the Grand Union Hotel, and in July 1895, it was remodeled and reopened as the New Rochester Hotel. By 1907, the building had been expanded to two sections and was later expanded to three sections. In 1920, the Kahler Corporation purchased the building and renamed it the Olmsted Hospital. In 1923, it became a home for Kahler nurses. In 1928, the building was moved three blocks in three sections (using horses) to 426 Second Avenue SW and renamed the Maxwell House to make room for the Model Laundry. The 70-room structure was the largest building moved in the city up to that time. In newspapers of the time, it was noted that it could have been moved in one piece except that it was felt that too many trees would have to be cut down to get the hotel around the necessary corners. In 1968, the Maxwell became the Maxwell Guest House. The Maxwell Guest House was demolished in 2007, mostly because it was old.

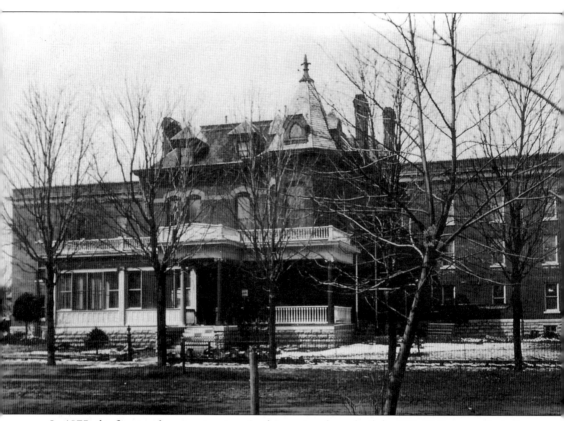

In 1875, the front and center structure in this postcard was built by J. D. Blake as a private home at 7 Second Avenue SW (7 South Franklin Street). In 1889, it was purchased by E. A. Knowlton of Knowlton's Department Store. In July 1906, the home was purchased by Rochester Sanitarium Company, whose general manager was John Kahler, and turned into the Kahler Hotel. Kahler originally came to Rochester to manage the Cook Hotel. A three-wing annex was added in May 1907, and in March 1913, the hotel was sold to the Kahler Hotel Company. When the current Kahler Hotel was built across the street in 1921, this hotel was renamed the Damon Hotel in honor of Hattie Damon Mayo, Dr. William J. Mayo's wife. Kahler died on January 20, 1931, at the age of 67. The Damon Hotel was later demolished to build the Damon Parkade aboveground and the Mayo Clinic Curie Pavilion for Radiation Oncology belowground.

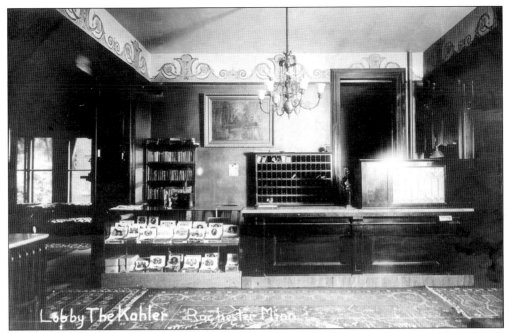

These great old real-photo postcards from 1912 show the lobby and sun parlor of the original Kahler Hotel. There are similar postcards of the music room, the blue room (which appears to be a dining room), and the lounging room.

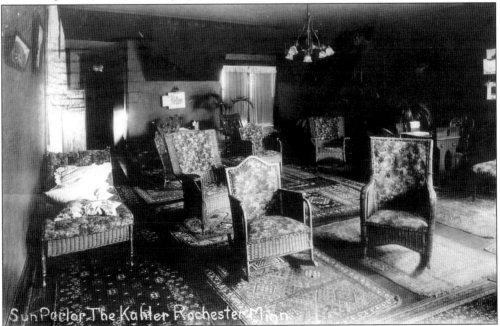

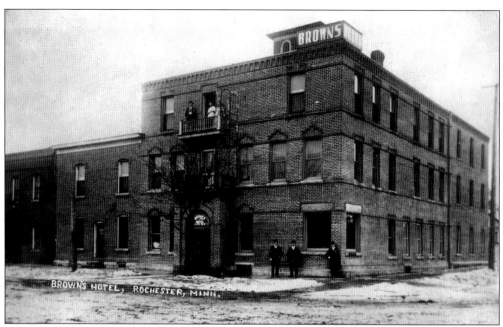

This building on the west side of First Avenue SW, across from the present-day Bilotti's, was built in 1864 and originally called the Norske Hotel. Shortly thereafter, it was renamed the City Hotel, and in 1871, the hotel was renovated and renamed the Merchants Hotel. In 1880, it was sold to William Perry and renamed the Perry House, and in 1882, it was sold to C. A. Merritt and the name reverted to the Merchants Hotel. In 1902, Warren H. Brown bought the hotel and changed its name to Brown's Hotel and later the Brown Hotel.

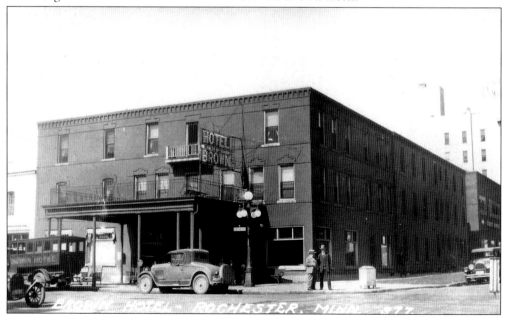

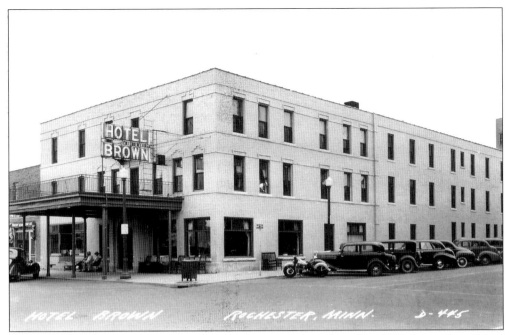

In 1974, the Kahler Corporation purchased the Brown Hotel, and in 1977, it was demolished for use as a parking lot. This is currently the site of the First Avenue Municipal Parking Ramp, which opened in 1998.

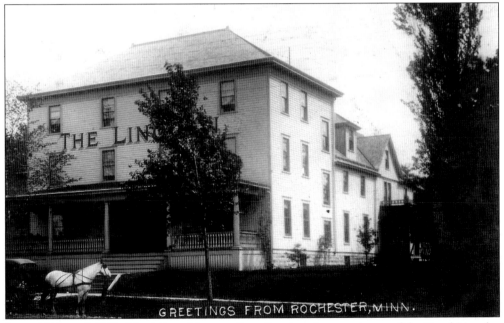

From 1909 until 1917, "the Misses Mangner" are listed as the proprietors of the Hotel Lincoln, which was located "one door east of Saint Mary's Hospital." Proximity to St. Marys was apparently a two-edged sword, for in the 1919 Rochester City Directory, the site of the Hotel Lincoln is listed as the St. Marys Hospital Annex.

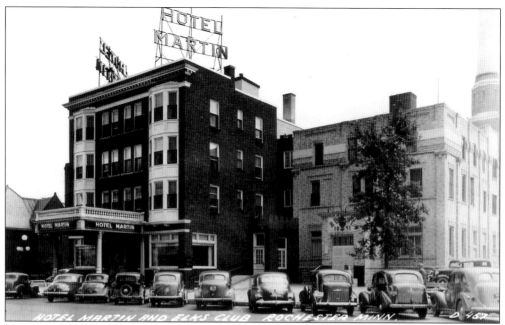

The Hotel Martin was built at 114–116 Second Street SW in 1916. Until recently, it was one of the few surviving early hotels of Rochester. The building to the right of the Hotel Martin is the old Elks Club, which is now part of the Conrad Hilton Blood Bank parking lot. In 1994, James Sadler bought the Hotel Martin and renamed it the Colonial Inn. The Colonial Inn was demolished in December 2007. At least initially, the site will be used as a parking lot for Mayo Clinic employee bicycles.

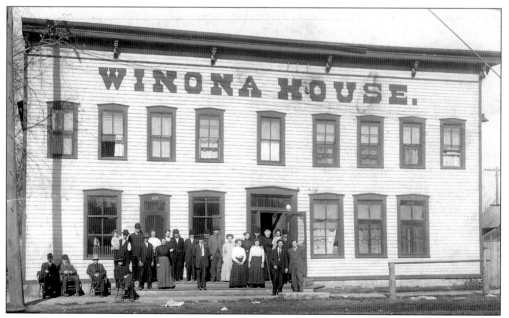

In 1869, Robert Smith erected the Winona House on the northeast corner of what is now Center Street and First Avenue NW. In 1919, Charles Grassle bought the hotel from Barney Wenting and razed it to build the Carlton Hotel on the site.

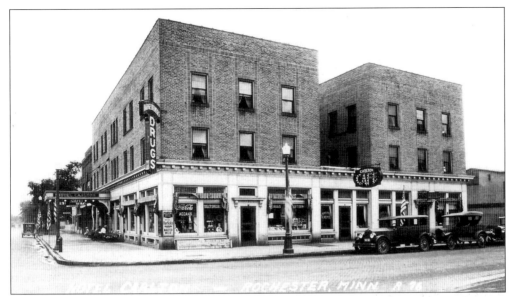

Built in 1920 by Grassle at 6 First Avenue NW on the site of the Winona House, the 50-room Carlton Hotel was named for one of Grassle's sons, Carlton. His other son, Paul, became general manager following his father's death. Paul was elected Rochester's mayor four times beginning in 1939. Later Paul's two sons, Wallace and Paul Jr., were added to the organization. This postcard is dated July 1925.

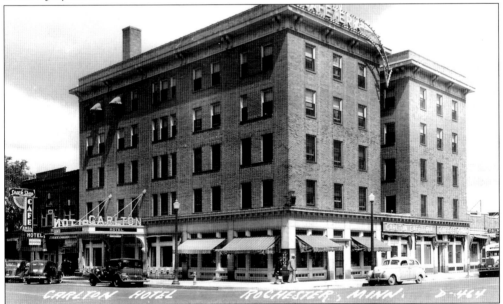

Several years after being built, 50 more rooms and two more floors were added, and as this 1930 postcard shows, the Carlton Hotel now has five floors. The Snack Shop restaurant and the other stores to the left of the Carlton were eventually demolished for parking. The Carlton is now called the Days Inn Downtown, and John's Family Restaurant, which occupied the hotel for a number of years, is now a Pannekoeken restaurant. With the demolition of the Hotel Martin, this structure is the sole surviving early hotel of Rochester other than the original section of the 1921 Kahler Hotel.

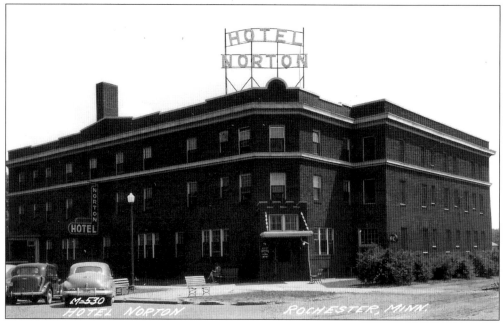

The Hotel Norton was built in 1915 at 104 Second Street SE, across the street from the current Rochester Public Library. It was destroyed by fire on February 6, 1967. The Fontaine Towers now occupy this site.

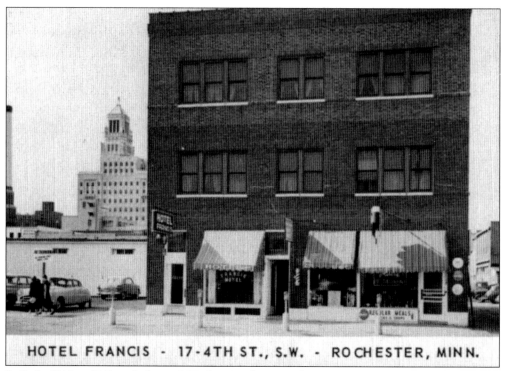

Built in 1918 at 17 Fourth Street SW, the Hotel Francis became the Candle Rose Inn in 1987. It was recently purchased by Olmsted County and renovated into subsidized housing.

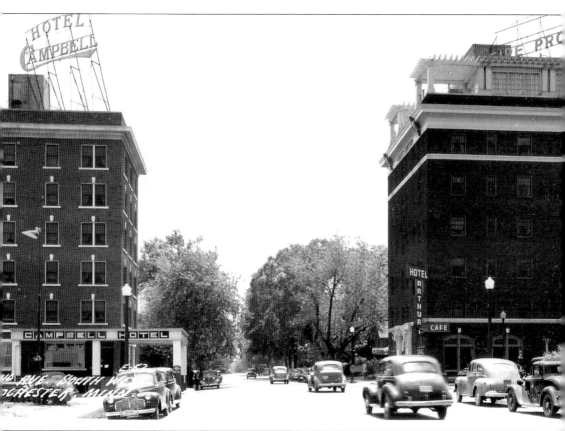

The Campbell Hotel opened in July 1920 on Second Avenue SW, directly west of (behind) the Brown Hotel, which is now the First Avenue Municipal Parking Ramp. It was demolished in 1999 and replaced by the Mayo Clinic Stabile Building, which opened in 2000. The University of Minnesota Genomics Research Center has subsequently been added to the top of Stabile Building. The Arthur Hotel was built in 1920 at 301 Second Avenue SW and was named after Arthur C. Gooding, one of its builders and a Rochester financier. It was advertised as "One of Rochester's Finest Fireproof Hotels—100 Choice Outside Rooms All With Private Toilet—70 Private Baths—Rates From $2.00 Single, $3 Double." The Arthur Hotel was demolished in 1982 for a parking lot.

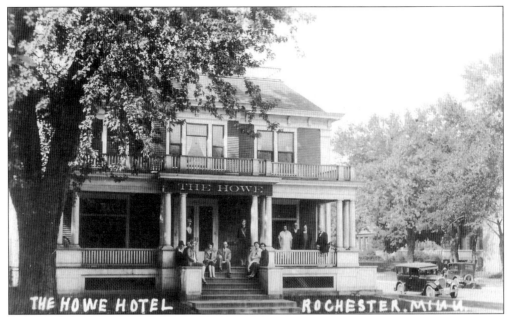

Originally located at 203 Third Avenue SW, the Howe Hotel was built in 1917 by E. E. Howe. It was sold to the Mayo Foundation in 1948 for the Rochester Child Health Institute and later became Desk O for the Child Psychiatry Section of Mayo. In 1954, the Aldrich Memorial Nursery School bought the building and moved it to 47 Thirteen and a Half Street NW where it remains. In 2007, the building was purchased by the Church of the Nazarene for housing Mayo Clinic patients and their families. The Mayo Clinic Harwick Building now occupies the original site.

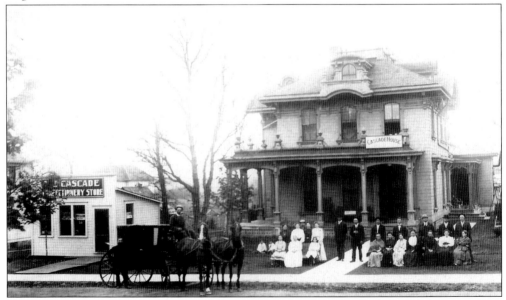

The Cascade House and Cascade Confectionery Store were located "directly opposite St. Mary's Hospital" on West Zumbro Street (now Second Street SW). They were owned by Gustave Schoenfelder and his wife and were named after nearby Cascade Road (now Eleventh Avenue SW), which, in turn, was named after Cascade Creek. This postcard is from about 1913.

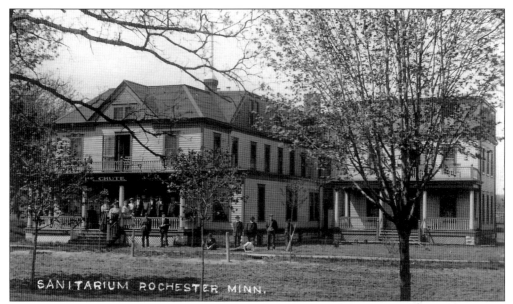

Sometime prior to 1903, Charles Chute and his wife opened the Chute Sanitarium in their residence at what is now the northeast corner of Second Avenue and Third Street NW just north of Central Park. In 1903, they were forced to seek larger quarters and acquired adjoining property, which they remodeled and added to their sanitarium. Again in 1907, they were compelled to make another large addition that enabled them to accommodate 65 patients. In addition to two hospital wards, the sanitarium also included an operating room. In 1911, the sanitarium was sold to Mark L. Towner, who operated it until 1917 when it was sold to Alton D. Watson and became the Watson Hotel. By 1948, it was called the Parkside Hotel, and by 1972, it was the Downtown Apartments. In July 1981, the building burned down. The Chutes seemed to enjoy having group photographs taken of their clients and turned into postcards, as these are two of many such postcards.

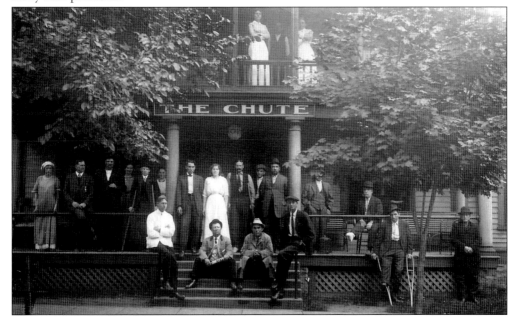

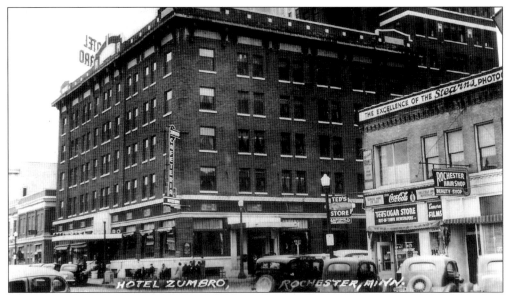

Completed in 1912, the Hotel Zumbro was designed by the Ellerbe and Round architectural firm for the Kahler Hotel Company. At the time, it was the largest hotel in southern Minnesota. In 1980, it was entered on the National Register of Historic Places. The hotel closed in August 1987 and was demolished in October 1987 to permit construction of the Kahler Plaza, which is now the Marriott Hotel. In this image, the Stearns Photography Studio is located on the second floor of the building on the right.

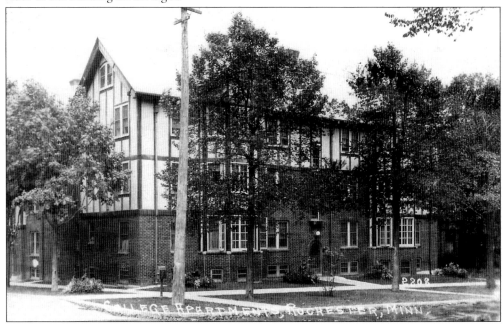

The College Apartments was constructed in 1918 by the Kahler-Roberts Corporation on the site of the former home of Dr. William J. Mayo. Mayo and his wife resided there until they moved to their new home, which is now the Mayo Foundation House. The College Apartments, with 47 units, was the first of the large apartment buildings in Rochester and was constructed at a cost of $200,000 for the building and site. It was demolished in November 2007.

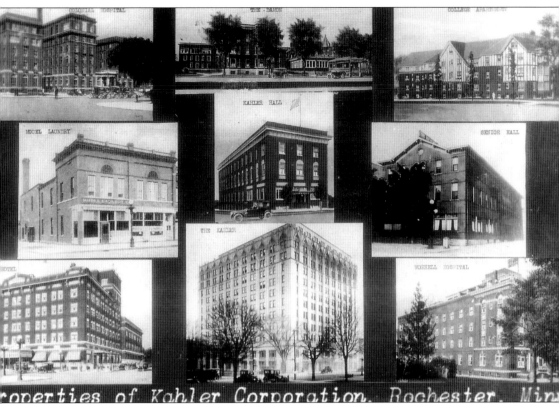

By 1923, the Kahler Corporation had accumulated quite a portfolio of Rochester properties. The building labeled Senior Hall served as a nurses' residence and was previously known as the Pierce House, Rochester Hotel, and Maxwell Hotel. The Damon Hotel opened in 1907. The Model Laundry opened in 1910. The Hotel Zumbro opened in 1912. The Colonial Hotel opened in 1915 as a two-wing hotel. In 1916, it was converted to a hospital, and in 1917, a south wing was added, increasing its capacity to 235 beds. Kahler Hall started life as the Kelly Hotel and was renamed the Stanley Hospital to honor Dr. Henry Stanley Plummer. It opened in 1917 with 51 beds and was enlarged in 1920 to include 62 beds, a nursery, an operating room, and two laboratories. The hospital was closed in 1921, converted to a dormitory for freshman student nurses, and renamed Kahler Hall. The College Apartments opened in 1917. The Worrall Hospital opened in 1919 and was originally intended for use as a nurses' dormitory. An annex, added in 1920, increased the bed capacity from 130 to 210, supplemented by nine operating rooms. The hospital was named for Dr. William Worrall Mayo, father of the Mayo brothers. The new Kahler opened in 1921. In October 1907, the Kahler Corporation was purchased by Sunstone Hotel Investors Inc. In 1999, Westbrook Partners acquired Sunstone.

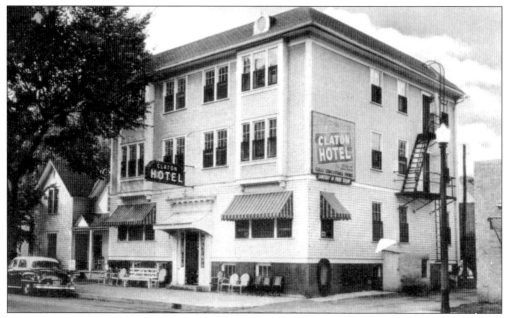

John Claton Crabb built the Claton Hotel at 215 West Center Street in 1917. From 1919 until about 1921, the building is identified in the Rochester City Directory as the Colonial Hospital Nurses Home and in 1923 as Senior Hall, but by 1925, it is back to being the Claton Hotel with Ellen Crabb as proprietor. The Claton was demolished in 1963 to make way for the Rochester Methodist Hospital.

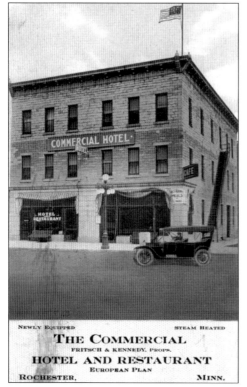

Located on the northeast corner of Broadway and Center Street, the three-story, hewn stone Commercial Hotel building was built in 1868 at a cost of $7,000. The building was rebuilt in 1910 but closed about 1969. The Bank Saloon occupied the site starting in 1970. This site now contains the Suk law firm building.

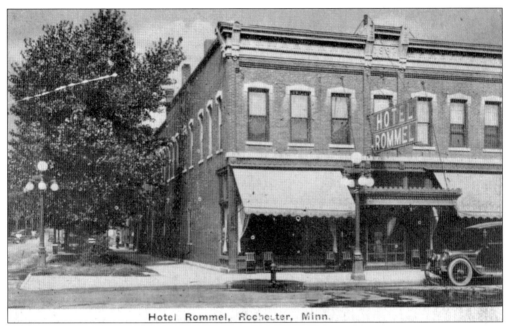

Hotel Rommel, Rochester, Minn.

The Hotel Rommel was built in 1915 on the northwest corner of Broadway South and Fourth Street SW. It was destroyed by fire in 1953 and replaced with a parking lot. For a long time, this parking lot was used first by Huey's Liquor Store and later by Carson Art Supply.

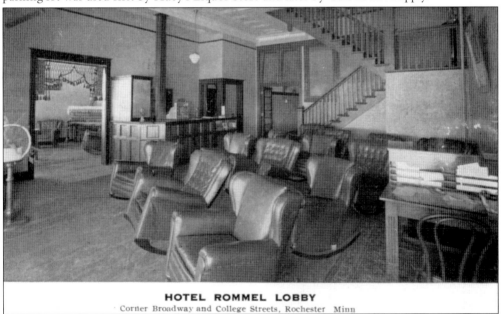

HOTEL ROMMEL LOBBY
Corner Broadway and College Streets, Rochester Minn

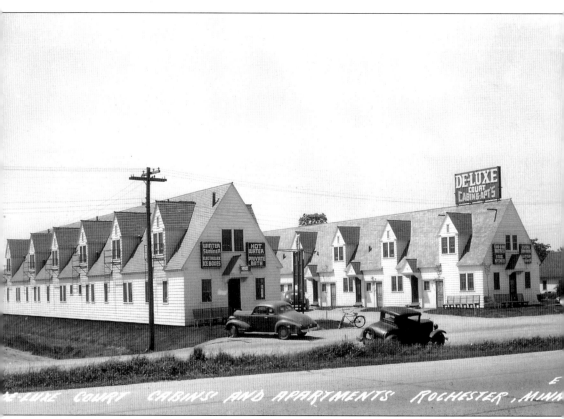

The Deluxe Court Cabins (later a motel) opened on Highway 52 South just south of Second Street SW in about 1942. They were a longtime landmark on the Highway 52 access road after the highway was expanded and excavated so that it could pass under Second Street SW. Originally each room had its own carport for protection against inclement weather, but later the carports were reworked into additional rooms. It was demolished as part of a subsequent Highway 52 expansion in 2001.

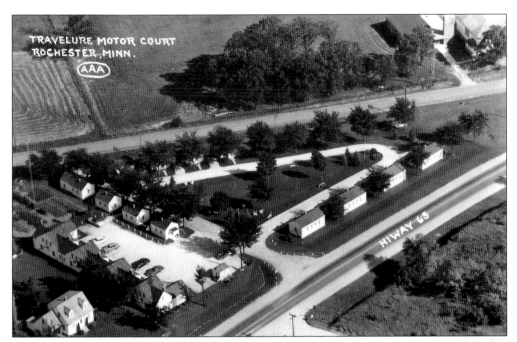

The Travelure Motor Court opened at 2214 Broadway South about 1940. It is one of the few survivors of a fairly large number of what were originally cabin-based accommodations in Rochester. The Travelure Motor Court is now a Red Carpet Inn.

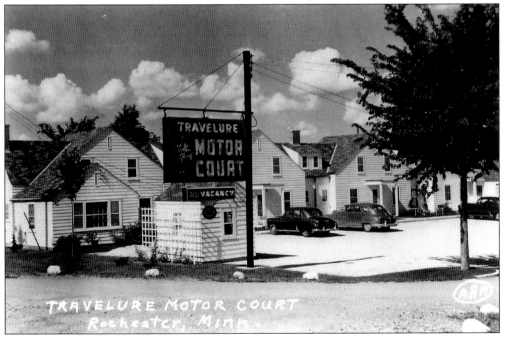

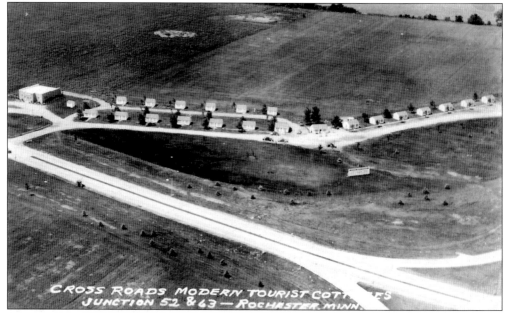

If one ever wonders how the Crossroads Shopping Center got its name, this postcard provides a big hint. The Cross Roads Modern Tourist Cottages were replaced by the Crossroads Shopping Center, which opened in 1962 and had its official grand opening on June 10, 1963. It is interesting to note Highway 63 in the foreground and the empty land behind the cottages.

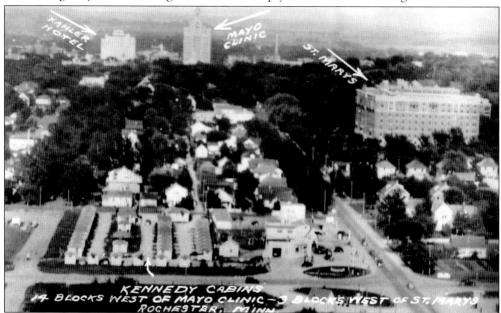

The Kennedy Cabins opened on Highway 52 about 1935. Highway 52 is visible just above the word *Kennedy* in Kennedy Cabins. What is fascinating about this postcard is that there is not even a traffic light at the intersection of Highway 52 with Second Street SW. In 1961, the Kennedy Cabins were replaced by the Kennedy Courtel. The Kennedy Courtel closed in about 1970 and was replaced by an Embers restaurant in about 1975. Embers was demolished in 2004 as part of the Highway 52 expansion.

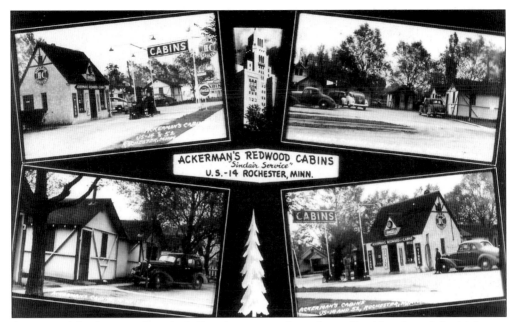

As automobiles became America's favorite means of travel, small cabins dotted the highways entering Rochester. These family-run businesses catered to the tourists and Mayo Clinic patients, who preferred lodging that was less expensive and more private than hotels and rooming houses. Ackerman's Redwood Cabins, which were located at 1146–1152 Seventh Avenue SE, first appeared in the Rochester City Directory in 1937. They were originally owned by Archie and Ora (Minnie) Ackerman, but by 1960, Archie is listed as the Rochester city treasurer. By 1968, he is listed as retired and the cabins no longer appear. This site is currently the parking lot for a Kentucky Fried Chicken restaurant.

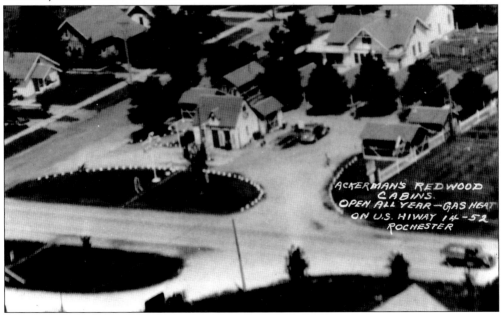

In 1918, John and Dorothy Case bought the 13-room Stoppel home (built in 1890) in the 300 block of First Street SW and renamed it the Hotel Virginia after their daughter. In 1927, a four-story brick addition was constructed at 103 Third Avenue SW. The proposed nine-story addition, shown on the right side of this postcard, was never built. In 1976, the hotel was purchased by Satisfaction Real Estate and renamed the Heritage House Hotel. In 1998, the building was razed to create a staging area for construction crews working on the Mayo Clinic's new Gonda Building. This site now contains the statuary garden just south of the new Damon Parking Ramp. The 1934 Rochester Post Office was just north of the Hotel Virginia and faced the right side of it from across First Street SW.

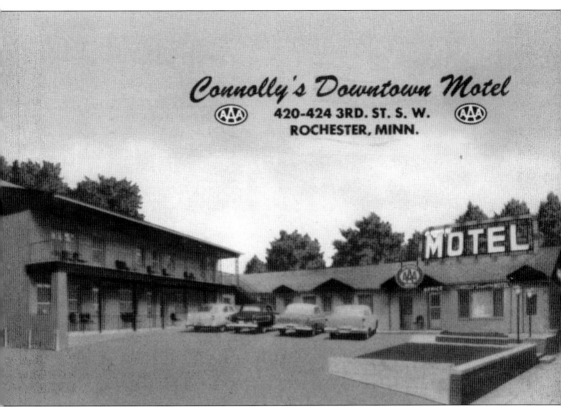

Connolly's Downtown Motel at 420–424 Third Street SW was built and operated by E. T. Connolly and his sons, Tom (and his wife, Ferne) and Don (and his wife, Nina), from the early 1950s to 1981. The first six units were built in 1951, and when they were paid for, the family started the next six and kept going until it had a total of 60 units. E. T. and his sons were plumbers by trade and did most the work themselves. The wives of the sons did all the bookkeeping and housekeeping for many years. E. T.'s wife, Ida, was the first beauty shop operator in Rochester and had a beauty shop on Broadway. In 1981, the motel was sold to the Mayo Clinic and operated by the Kahler Hotel Company for a number of years. Most of the motel was eventually demolished to build the brand-new Opus Building Center for Advanced Imaging, but one section of it remains just north of the Opus as the Radiology Research Center.

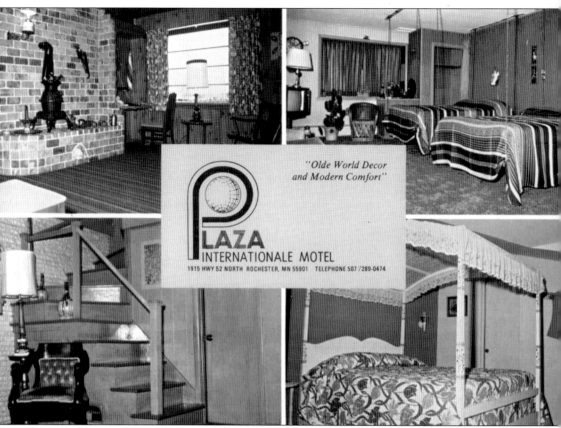

The Plaza Internationale Motel was built in 1958 by Wesley Jameson at the intersection of the Highway 52 North access road and Elton Hills Drive (near IBM). In accordance with its name, the motel contained internationally themed rooms representing the decor of Scandinavia, Germany, China, Brazil, France, Polynesia, Hawaii, Mexico, and Italy. Later Sweden, Norway, Monaco, the old West, Egypt, Greece, India, Lithuania, Honduras, and Orion (the Star Room) were added. In 1975, the motel was purchased and renovated by Jay and Marian Bagne, who added the Internationale Marketplace shops. The motel also contained Gulliver's Restaurant, the C'est When Lounge, and later the Willows Restaurant (1993 to 1994) owned by Wongs. The Plaza Internationale was demolished in 2001 as part of the Highway 52 expansion project.

Three

RESTAURANTS

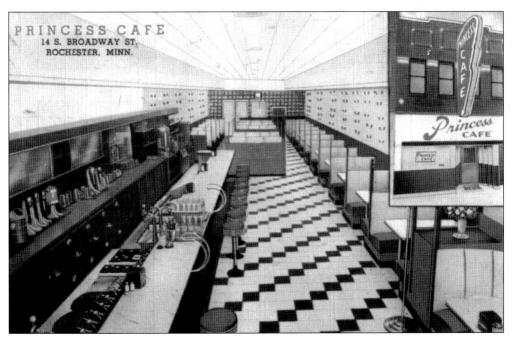

In 1910, brothers Harry and Christ (pronounced Chris) Margellos came to Milwaukee from Greece. They later moved to Duluth, and their younger brother John joined them in 1914. In 1919, Harry and Christ moved to Rochester to run the concession at the Garden Theater. Shortly after, they purchased the building at 14 Broadway South, demolished it, and built a new building. The Princess Cafe opened in 1921 as the Princess Confectionery, a candy shop. In 1924, John joined them, and in 1927, the building was expanded to 25 booths and Harry married Anastasia Dimas. George Margellos was born in 1929. The Princess Cafe closed on March 20, 1976, and the building was sold to the Barbers. The site is now occupied by the Broadway Plaza condominiums.

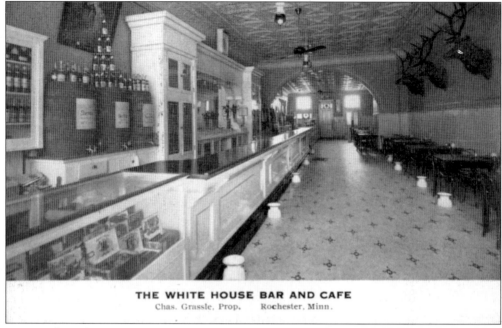

THE WHITE HOUSE BAR AND CAFE
Chas. Grassle, Prop. Rochester, Minn.

In 1910, the White House Bar and Cafe (also known as the White Front Saloon) was located at 110 Broadway South. It was owned by Charles Grassle, who built the Carlton Hotel in 1920.

The mural shown on this postcard graced the wall of Morey's Bar and Cafe, which was also at 110 Broadway South from 1935 until 1957. On May 3, 1958, Eddie Webster's Super Club replaced Morey's, and the fate of the mural is unknown. In 1933, prior to Morey's, 110 Broadway South was occupied by the Canton Cafe, which was owned by Henry Wong. Wong was unrelated to the Wongs who later opened Wong's Cafe on Third Street SW. This location housed a Swiss Colony store from 1964 to 1971 and Duling Optical starting in 1972. The Radisson Hotel now stands on this block.

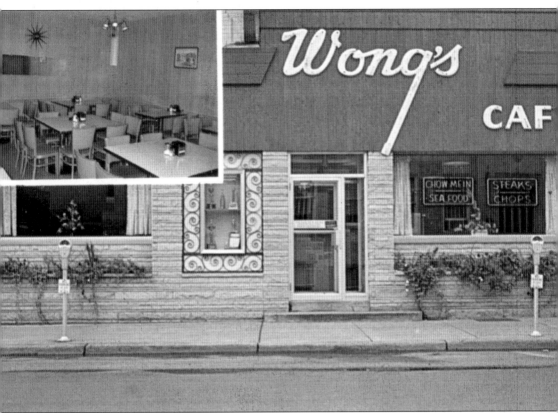

The original Wong's Chinese restaurant was opened in September 1952 at 20 Third Street SW by brothers Ben and Neil Wong and their wives, Mae and Poya. In 1982, the senior Wongs sold the business to Ben and Mae's son Stephen, along with Neil and Poya's son Dennis and his wife, Lynn, and daughter Virginia and her husband, Ron. Stephen and Dennis were both practicing lawyers at the time. In 1983, Wong's moved to the former site of the Union National Bank Building and Reeve's Drugstore on the southwest corner of Broadway and Third Street SW. Wong's closed on Friday, December 23, 2005. It recently reopened under new management in the Elks Club at Hillcrest Shopping Center. The building on Third Street now contains the Nordic Gypsy bead shop. The building at the southwest corner of Broadway and Third Street SW is now Sontes Restaurant.

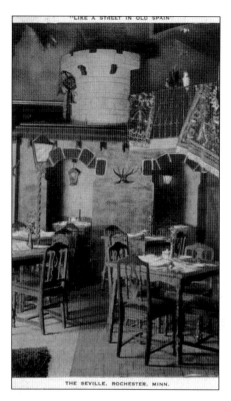

The Seville Cafe was located on the ground floor of the IOOF Building at 23 Second Street SW from 1928 to 1936. It was owned by brothers Michael and George Sakell and was originally the Olympia (a Greek restaurant) from 1913 until 1928. From 1937 to 1941, this site contained Austin's Restaurant, and in 1943, it became the Green Parrot Cafe. One unique aspect of this location is that it can be entered from either Second Street SW or from First Avenue SW.

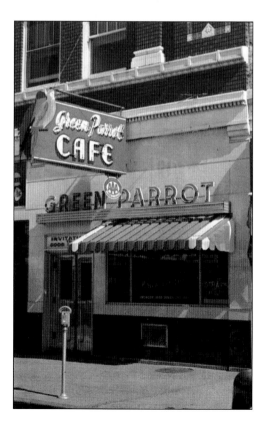

The Green Parrot Cafe occupied this site at 23 Second Street SW from 1943 until it closed in 1986. Prior to 1943, the Green Parrot Cafe had been in the Cook Hotel. This location now contains the Eagle Drug Store.

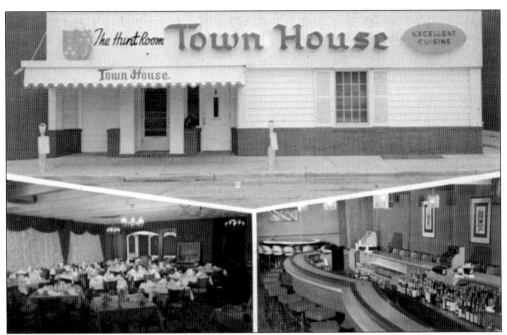

The second Town House restaurant was a popular restaurant, located at 10 First Avenue SE (just north of the current Post Bulletin building main entrance) on the ground floor of the President Hotel. It was destroyed in a fire on November 4, 1983. The first Town House restaurant was located at 17 Second Street SE, which is now the Radisson parking ramp, and it burned down in December 1953.

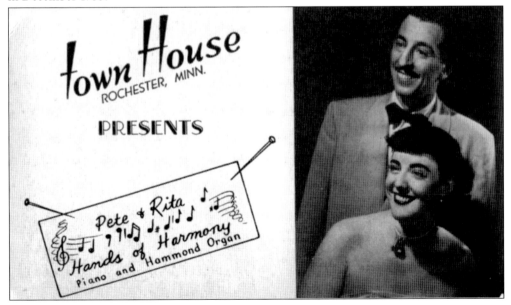

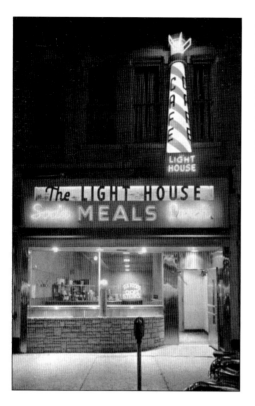

Located at 19 Second Street SW in what was the Brackenridge Building, the Light House Cafe was one of Rochester's oldest cafés. It was known as Thurber's Cafe from 1927 until 1948 and the Light House Cafe from 1950 to 1956. Lyman's Department Store was located next door to the right. The Brackenridge Building was demolished in 1956 in order to build the Northwest National Bank building.

Originally built for the Casseday Marble and Granite Works (later Anderson's Rochester Granite and Monument Works), this building at 216 First Avenue SW was purchased by Newton Holland in 1930 for his grocery business. In 1944, the grocery business was converted to Holland's Cafeteria, and in 1953 a second-floor dining room was added. Holland died on August 17, 1963, at age 66. Holland's Cafeteria closed in 1970. Holland was a strong advocate for the arts and instrumental in the creation of the Rochester Art Center in 1946. He served as its president for 12 years. Since Holland's, this building has housed a series of restaurants, including the Bank Restaurant, Henry Wellington's, and the City Cafe. Newt's Bar on the second floor is named for Newt Holland.

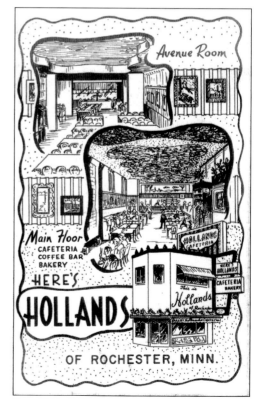

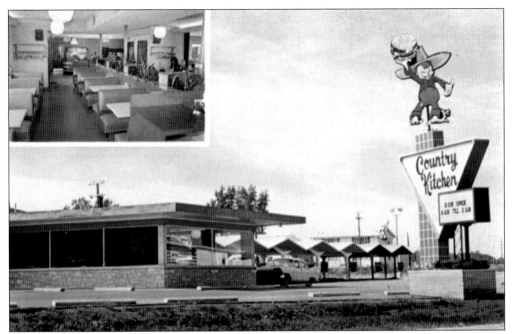

This longtime Rochester favorite started life as Carter's Country Kitchen Drive-In. The building now contains Daube's Bakery. The large free-standing sign is still there although it has been substantially modified. For example, the country boy has been transformed into a baker. Carter's opened about 1962 and closed about 1989.

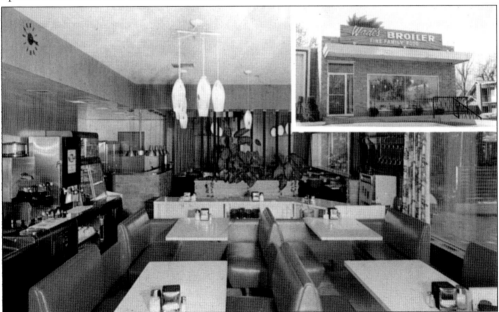

Willard Wade opened Wade's Broiler in 1958 on Highway 52 "across from miracle mile," just north of Johnson's Standard station (see page 124). Wade's was one of only a few Rochester restaurants that were open 24 hours at the time. After Wade's closed in 1990, the site contained the Magic Wok for a short time and later the Asia Cafe. The building was demolished in 2004 as part of the Highway 52 expansion.

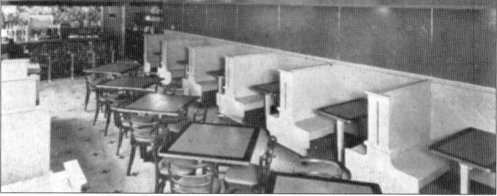

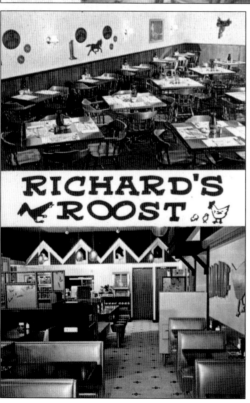

Both of these restaurants were located at 13 First Street SW next to the Chateau Theatre. Hargesheimer's Restaurant was located there from 1938 until 1962, and Richard's Roost (named after its owner Richard Hargesheimer) was there from 1963 until 1985. Hargesheimer's Drug Store stood for many years on the northwest corner of Broadway and First Street SW. This location and the drugstore were demolished in 1987 to build the Galleria Mall, now the Shops at University Square.

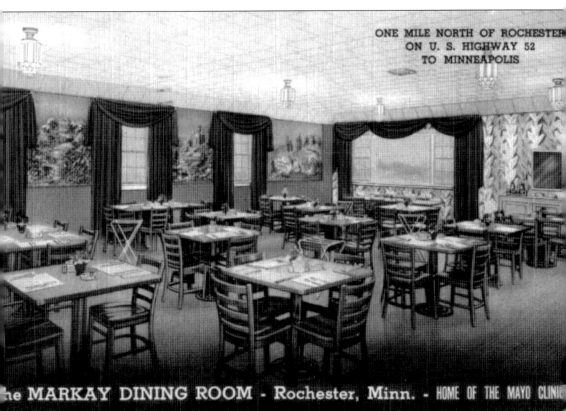

The Markay Dining Room was named after its owners, Mark and Kay Carroll. It existed from 1948 to 1964. An early advertisement describes the Markay as "the only eating place in Rochester with male wait staff." Of particular interest is the comment on the postcard that the Markay was "one mile north of Rochester on U. S. Highway 52 to Minneapolis." In 1937, this site contained the Nite Club. In 1965, the Markay was replaced by the Golden Garter Tavern, and in 1966, the Golden Garter became Golden George's Tavern, a pizza restaurant. In 1984, Golden George's Tavern was replaced by Raspberry Brown's restaurant. In 1988, the Blueberry Hill restaurant opened, and in 1990, the Smiling Moose opened. This building was demolished about 2002 as part of the Highway 52 expansion project.

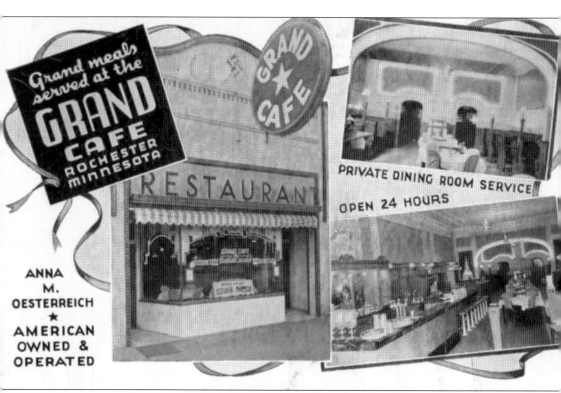

In 1915, 15 Broadway South contained the Grand Theater, a motion picture house with a seating capacity of 450. By 1921, the site contained the Grand Cafe, and in 1933, the Grand Cafeteria was there. From 1934 until 1938, the restaurant was called the Golden Arch Cafe, but by 1940, it was the New Grand Cafe. In 1947, it was renamed the Steak House, and in 1950, it was called Leaf's Cafe. In 1951, this site became Michaels Restaurant, and eventually part of the original building was incorporated into one of Michaels's numerous expansions.

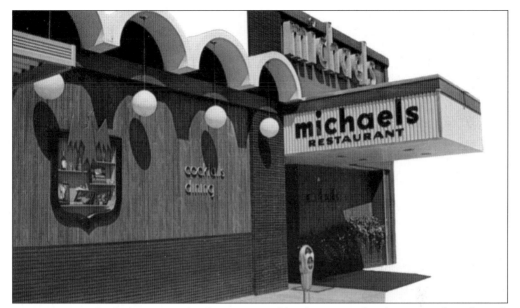

Since 1951, Michaels Restaurant has been operated by the Pappas family as one of Rochester's premier restaurants. Parents Michael "Grandpa Mike" and Mary Pappas brought their daughter and four sons, Paul, George, Jim, and Chuck, to Rochester from Worthington. For a number of years, they operated a lunch counter at the Brown Derby. From 1947 until 1951, George and Chuck operated the Old Covered Wagon restaurant east of the city on Highway 14 near the Pla-Mor ballroom. In 1951, they opened a small restaurant downtown at 15 Broadway South, named for their father. Grandpa Mike died in 1953. George died in 1969.

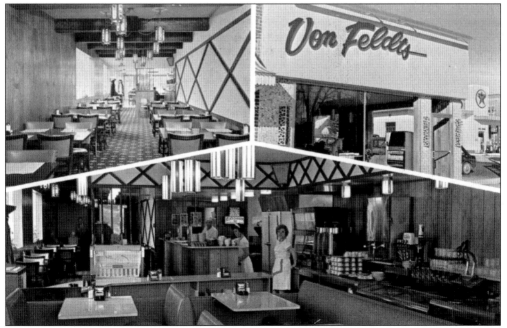

Von Feldts Restaurant opened at 611 North Broadway in 1964 and closed in 1977. This site currently contains the Kismet Home Furnishings consignment store. Before the restaurant was opened on North Broadway, the Von Feldts Cafe was located in the Miracle Mile Shopping Center.

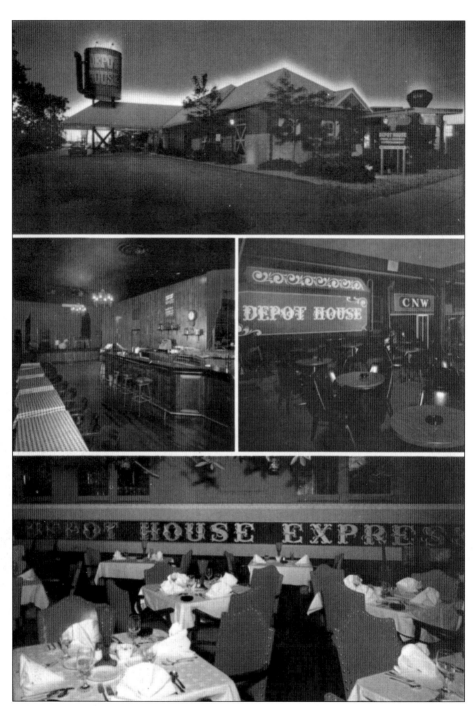

The Depot House restaurant was located on North Broadway in what had been the Chicago and North Western Railroad depot, which was built in 1890. Passenger train service in Rochester ended in 1963. The Depot House opened in 1967 and closed in 1979. After the restaurant closed, the building housed the Salvation Army Thrift Store for a short while. The building later fell victim to the construction of Civic Center Drive and was demolished in 1989. The train, a 1915 steam engine, was sold and moved to the Wheels Across the Prairie Museum in Tracy.

Four

CHURCHES AND RELIGIOUS INSTITUTIONS

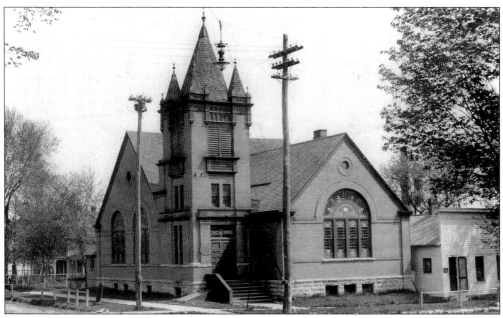

The First Christian Church, also referred to as the Church of Christ, was dedicated on February 28, 1897. It was located on the northeast corner of what are currently Fourth Street and Second Avenue SW, or "three blocks south of the clinic." In 1965, because of the growth of Rochester due to the coming of IBM and the need for expansion, a new church was constructed in northwest Rochester, and this building was sold to the Northwestern Bell Telephone Company. It was demolished in March 1966.

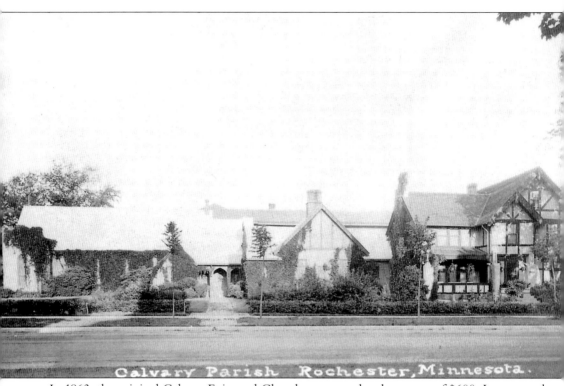

In 1863, the original Calvary Episcopal Church was completed at a cost of $600. It measured 27 feet by 55 feet. In 1864, the first church bell in Rochester was installed in the new church. The church was expanded in 1868, and the first rectory was built and occupied in 1885. The first guildhall was added in 1891, and further additions were made in 1900. In 1917, a new guildhall, designed by Harold Crawford, was dedicated. In 1958, after extensively studying the need for a larger church, it was decided to retain the existing site as a downtown church and to build a mission church to be known as Calvary Episcopal Mission. The Calvary Episcopal Mission Church opened in 1962 in northwest Rochester. On January 1, 1964, the mission church was renamed St. Luke's Episcopal Church. Calvary Episcopal Church is the sole surviving original church in the Rochester downtown business and medical district.

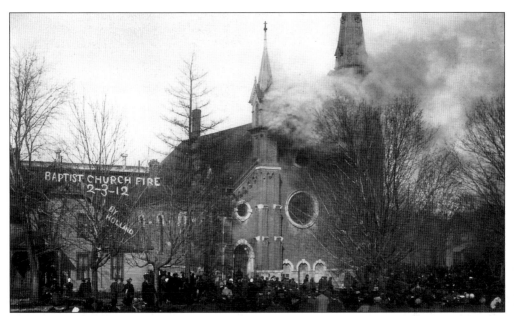

The first First Baptist Church, Rochester's first church building, was located just east of Broadway along the Zumbro River where the Hotel Norton was later built. The second First Baptist Church was built in 1870 where the Gonda Building now stands on the southwest corner of what is now First Street SW and Second Avenue SW. On March 9, 1912, a spectacular fire gutted this church.

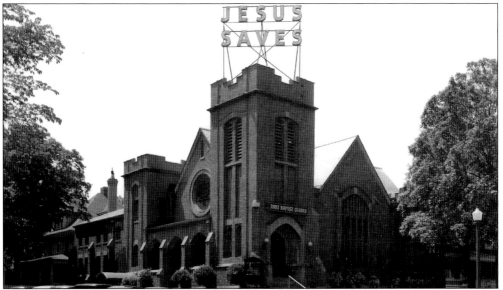

The third church, shown here, was constructed on the southwest corner of Fourth Avenue and Second Street SW and was dedicated on April 25, 1914. It was expanded in 1960. In 1969, this church was sold to the Mayo Clinic. This site now contains the Baldwin Building. The congregation bought the Zumbro Lutheran Church building on Third Avenue SW between Fourth and Fifth Streets. The Jesus Saves sign from the third church is currently being used by the Faith Christian School behind the Cornerstone Evangelical Free Church on Fortieth Avenue SE, just off Marion Road.

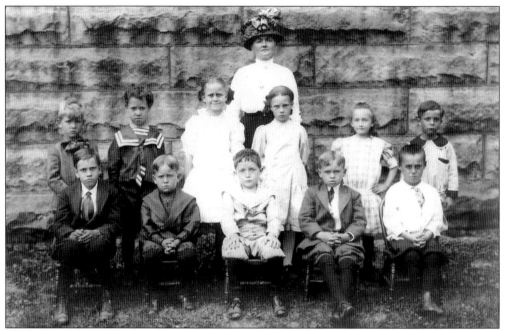

The children in this Baptist Sunday school class in 1912 do not seem particularly happy to be there, or more likely, they were not too enthusiastic about having to get all dressed up and pose for the photographer.

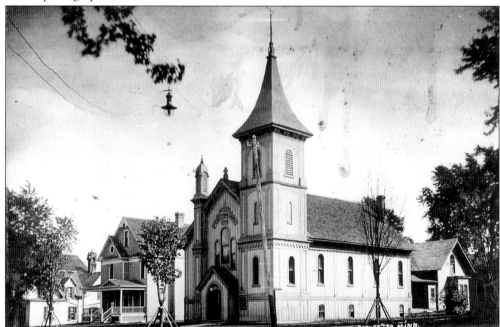

The First Presbyterian Church shown in this postcard was constructed in 1866 on the southeast corner of what is now Second Street SW and Third Avenue SW. In 1930, the church was partially damaged by fire and the congregation decided to build the current church on the southwest corner of Third Street and Fifth Avenue SW. The site of the original church was purchased by the Mayo Clinic and given to the City of Rochester as a site for the 1937 Rochester Public Library.

The original St. John's Church faced south and was located on the northeast corner of what is now Fifth Avenue SW and First Street SW. It was completed at a cost of $40,000 and dedicated on December 1, 1872. Several additions were completed in 1905 at a cost of $60,000. The priest's residence was built about 1909. The current St. John's Church was built in 1956. The building in the foreground was located on the northwest corner of Fourth Avenue SW and First Street SW, where the left front of St. John's Church is now. It opened in 1913 as a Catholic high school for boys and was originally called Heffron High School. It was run by the Christian Brothers and named after the Most Reverend (later Bishop) Patrick Heffron. St. John's School for Girls also opened in 1913 but as a Catholic high school for girls as well as a Catholic elementary school. St. John's School was located on the southeast corner of Fifth Avenue SW and Center Street on the diagonally opposite corner of the block from Heffron High School. In 1925, the Christian Brothers left Rochester, and the students at Heffron transferred to St. John's School. The Heffron school was made into an elementary school with grades 7-12 (girls and boys) occupying St. John's. In 1940, plans for a new St. John's high school building were disclosed. In March 1941, it was announced that the new high school would be called Lourdes High School since by then additional parishes besides St. John's had been started in Rochester (namely St. Francis). The name Lourdes High School was selected in honor of the first Catholic school in Rochester, the Academy of Our Lady of Lourdes, which opened on December 3, 1877.

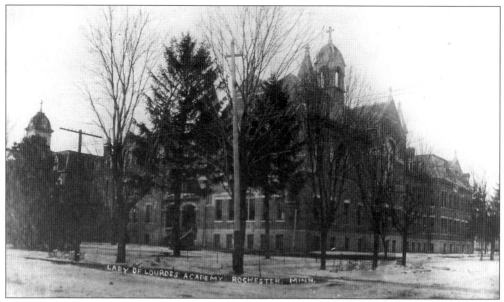

The Academy of Our Lady of Lourdes was built in 1877 at 514 West Center Street at a cost of $32,000 and was originally a day school for boys and girls, a boarding school for young women hoping to become nuns, and a convent. An addition was built in 1888. The boarding school moved to Winona in 1894. After Heffron High School and St. John's School were built in 1912, the Academy of Our Lady of Lourdes served primarily as the motherhouse for the Sisters of St. Francis until 1955 when Assisi Heights opened. This site currently contains the Mayo Clinic Employee West Parking Ramp.

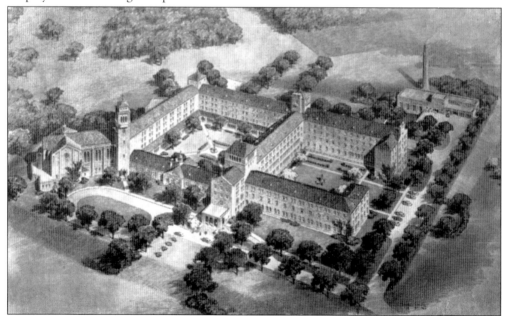

Located on approximately 100 acres in the heart of Rochester, Assisi Heights sits on top of one of the highest hills in Olmsted County. The Italian Romanesque structure was designed to resemble the Basilica of St. Francis in Assisi, Italy. Assisi Heights was dedicated on October 4, 1955, (the day of the Feast of St. Francis) as the new motherhouse for the Sisters of St. Francis.

The First Methodist Episcopal Church was organized in Rochester in 1857. In 1858, the first chapel was built at the northeast corner of what is now Center Street and Second Avenue NW. In 1867, the first brick church building was built on this site. The 1867 building was destroyed by the 1883 tornado and rebuilt and dedicated the following year. In 1914, the church building was demolished, and in 1915, a new church (shown here) was built on the same site. In 1958, the parish (now known as Christ United Methodist Church) built a new building at its present location on the southeast corner of Fourth Street and Fifth Avenue SW. The site in this postcard now contains the Rochester Methodist Hospital.

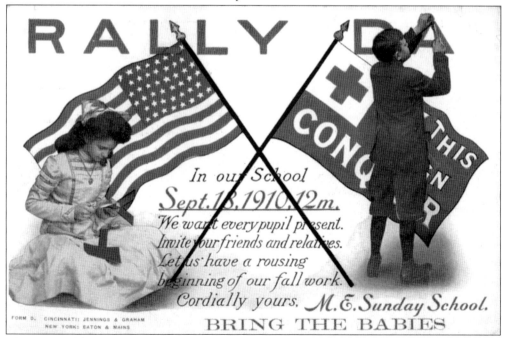

This postcard from 1910 encourages attendance at the Methodist Episcopal Sunday School Rally Day Program. In addition to a violin solo and several hymns, the program calls for a cradle roll call with a carnation for every member present, a recitation of "The Hero of a Midnight Charge," and 15 minutes for refreshments.

In 1866, the Universalist Church was first organized with 30 members in a small frame building on the lot where the Plummer Building is now located at the northeast corner of Second Street SW and Second Avenue SW. In 1874, the existing building was moved to the back of the property and a new building (seen here) was dedicated in 1877 and called the Grace Church. In 1889, a fire damaged the church building and it was rebuilt. In 1890, the Universalist Church brought the first pipe organ to Rochester. In 1916, the property owned by the church was sold to Dr. William J. Mayo and Dr. Charles H. Mayo.

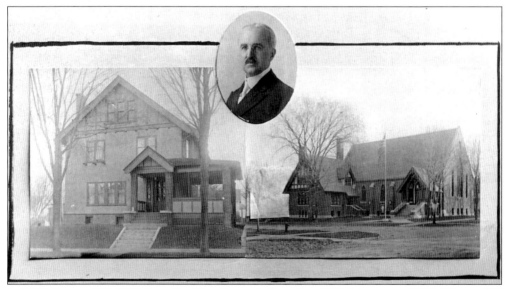

In 1916, the new (third) Universalist Church was dedicated on Third Avenue and Third Street SW on land the Mayo partnership sold to the church. In 1966, the land and church were sold to the Mayo Foundation and the current (fourth) Universalist church, called the Unitarian Universalist Church, was constructed in southwest Rochester.

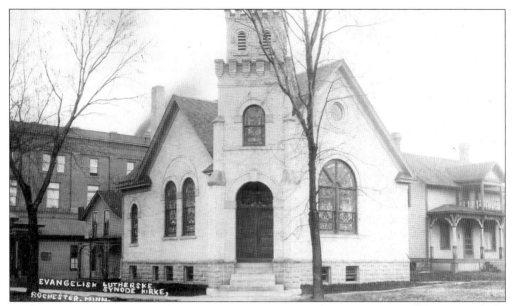

The Zumbro Lutheran Church was originally named the Norwegian Evangelical Lutheran Church of Rochester, Minnesota. In 1909, a church, known as the Little Church on the Corner, was constructed on the southeast corner of Second Street SW and Second Avenue SW. The Hotel Martin is visible in background on the left. In 1926, this church property was purchased by the Mayo Clinic to facilitate utility connections between the Franklin Station and the Plummer Building. Mayo demolished the church building in 1934.

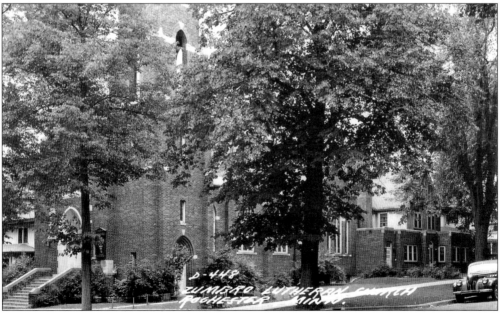

In 1927, services were first held in the new Zumbro Lutheran Church at the corner of Fourth Street and Third Avenue SW. In 1964, because of the growth in the parish, it decided to build another new church at the corner of Sixth Street and Third Avenue SW. In 1970, the former church building was sold to the First Baptist Church parish as an interim location between selling its building on Second Street and moving into its new building on Sixteenth Street SW.

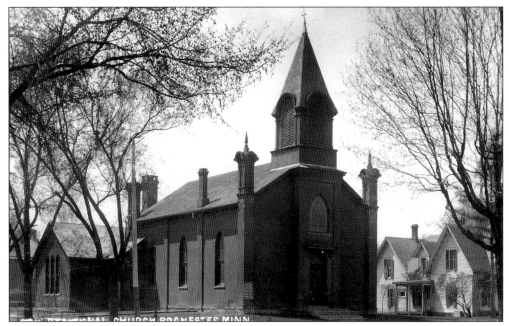

The original Congregational Church was first used for religious purposes in December 1864 but was not fully furnished until the autumn of 1866. It was located on the southwest corner of what is now Second Street SW and Second Avenue SW. The tornado of 1883 destroyed the tower of the church, and it was replaced in 1887. This postcard from about 1910 depicts the church with the new tower.

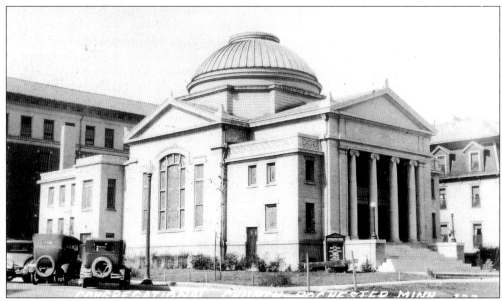

In 1916, the original Congregational Church was demolished and a new church, frequently referred to as the "White Temple," was constructed on the same site. Services were held in the nearby YMCA during construction. In 1963, the property was purchased by the Mayo Clinic. In 1964, the Congregational Church moved to its new location in southwest Rochester. This site now contains the Conrad Hilton Blood Bank building.

In 1869, the Trinity Lutheran Church, which was originally called the German Lutheran Church, was constructed on the corner of Second Street and Second Avenue NW. The church was severely damaged by the 1883 tornado. A rededication ceremony was conducted after the repairs were completed, and this was the first service to be preached in English. Previous services had all been in German. In 1894, the second church building (shown here) was constructed at Center Street and Third Avenue SW. Later this property was bought by the Mayo Clinic and the Damon Parkade and Curie Pavilion were constructed on this site. It now contains the Gonda Building. The present church, located at Third Street and Sixth Avenue SW, was built in 1951.

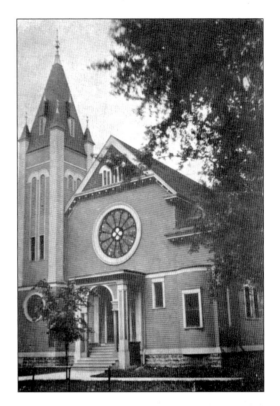

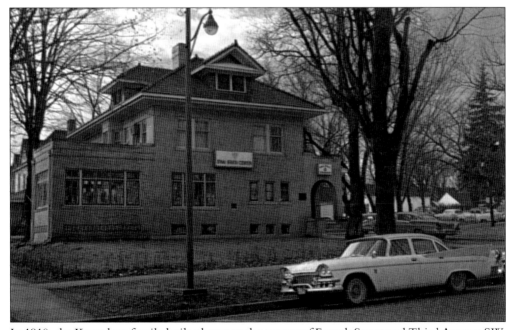

In 1910, the Knowlton family built a home at the corner of Fourth Street and Third Avenue SW. In 1944, members of the Jewish community in Rochester purchased this home for the B'nai B'rith Center, and it later became the synagogue. In 1978, they purchased the former Mormon chapel on Second Street SW, and the Knowlton property was sold to the Mayo Foundation.

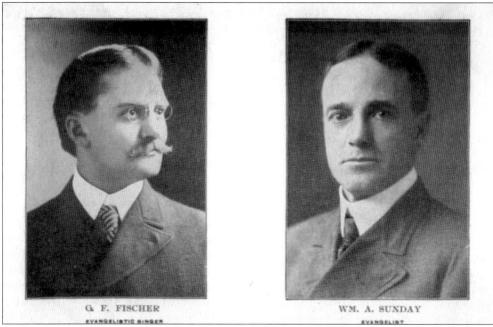

G. F. FISCHER
EVANGELISTIC SINGER

WM. A. SUNDAY
EVANGELIST

In January 1906, Rev. William A. (Billy) Sunday, a one-time Chicago baseball player, conducted a monthlong religious revival meeting in Rochester. The initial funding for the original Rochester YMCA was an outgrowth of this revival meeting. The tabernacle, which was built specifically for the revival meeting, was located on the northeast corner of First Avenue and First Street NW. Sunday died in November 1935.

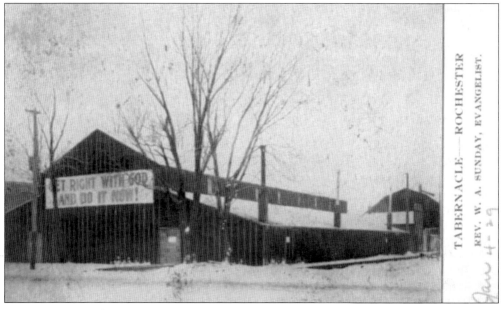

Five

MEDICAL COMPLEX

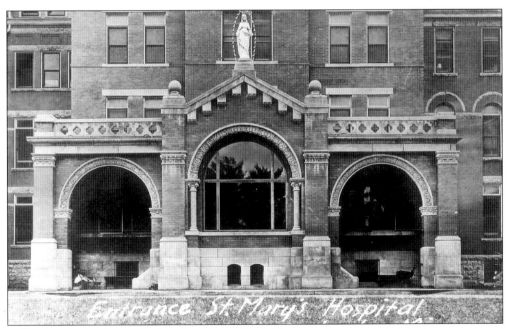

Following the 1883 tornado, Mother Mary Alfred Moes, mother superior of the congregation of Our Lady of Lourdes, went to Dr. William W. Mayo to suggest the construction of a hospital. Mayo told her that Rochester was too small and that she would never be able to raise enough money. When she persisted, Mayo agreed that he and his sons would staff the hospital if she could raise $40,000 to build it. By 1887, the sisters raised the money. The original St. Marys Hospital opened in 1889 with 45 beds.

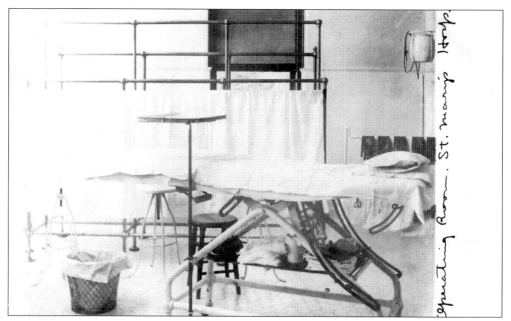

By the 1920s, more operations were performed at St. Marys Hospital than at any other American hospital.

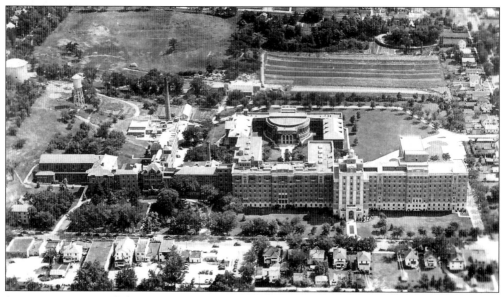

St. Marys was expanded in 1894, 1898, 1903, and again in 1909, by which time it had 360 beds and six operating rooms. A huge addition in 1922, later renamed the Joseph Building, almost doubled the capacity of the hospital to 650 beds. The Francis Building was added in 1941, the Domitilla Building in 1956, and the Alfred Building in 1967. In 1980, the Mary Brigh Building was added with almost 100,000 square feet on one floor and 43 operating rooms.

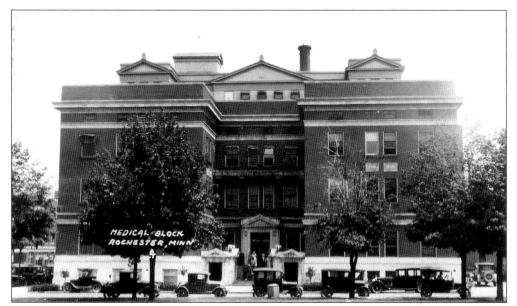

The 1914 Clinic Building, which is also sometimes referred to as the Medical Block, was largely designed by Dr. Henry S. Plummer, who later also designed the 1928 clinic, which is now called the Plummer Building. The 1914 Clinic Building was constructed on land that was previously the site of Dr. William W. Mayo's home. The 1914 Clinic Building was demolished in 1986 to make way for the Siebens Building, which opened in 1989.

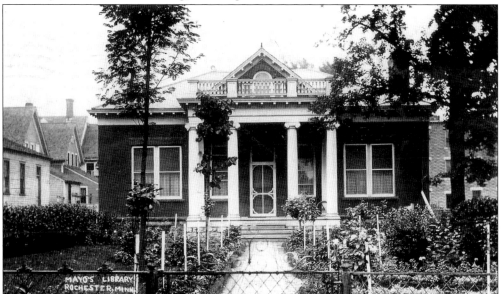

In 1907, Dr. William J. Mayo hired Maud Mellish "to organize and develop a library and to do editorial work in connection with the publication of papers." The library at that time consisted of the books in three small cases and the journals on a small reading table. It rapidly grew, however, and in 1909, a small library building (shown here) was erected to house it. Within three years, this building was outgrown and consideration of enlarging it in 1912 led to the decision to provide ample room for a library in a general clinic building, the 1914 Clinic Building. Sometime prior to 1928, the original library building was demolished to make way for the Plummer Building.

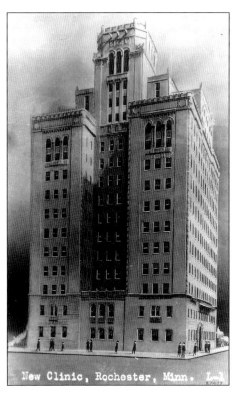

New Clinic, Rochester, Minn. L-1

The 1928 Mayo Clinic Building, later known as the Plummer Building, was designed by Dr. Henry S. Plummer in consultation with the Ellerbe architectural firm. The 12-story building was originally designed to have a flat top, but while visiting Europe, Dr. William J. Mayo discovered magnificent carillon bells and was so taken by their beauty that he ordered a duplicate set. Since there was no conceivable space in the building, the only answer was to create a belfry at the top of the structure. The original 23 bells weighed nearly 18 tons, with the largest bell, at almost six feet tall, weighing 7,840 pounds. An additional 32 bells were added in 1977.

Dr. Henry S. Plummer is credited with many of the innovative ideas that were implemented at the Mayo Clinic and St. Marys Hospital during his tenure. Among the most outstanding were his invention of a pneumatic-tube system for getting information where it needed to be, a communication system utilizing colored lights and flags outside examination rooms, a system of underground passages connecting the various Mayo buildings, and the Mayo Clinic's record-keeping system.

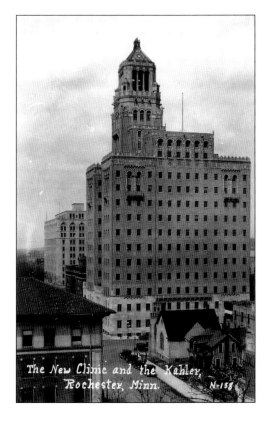

The New Clinic and the Kahler, Rochester, Minn. N-158

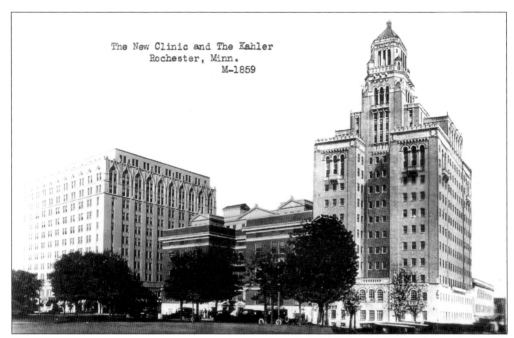

This postcard from about 1928 clearly shows the relationship of the Kahler Hotel to the Medical Block (1914 Clinic Building) and the Plummer Building ("the New Clinic").

Joseph L. "Joe Clinic" Fritsch was the attendant at the doors of the clinic's Plummer Building for about a quarter of a century and thus the first person patients saw when they came to the clinic. Fritsch had the knack of making friends with almost everyone and was among those rare individuals with total recall for matching names to faces many years after meeting the person for the first time. He was born in England in 1901. In 1920, he joined the general service staff of the clinic. In 1928, he was assigned as attendant at the doorway of the newly completed Plummer Building and remained there until 1947. He later served as greeter at the Mayo Building, and in 1963, he returned to the Plummer Building information desk. It was chiefly through the mail that Fritsch was dubbed "Joe Clinic" as the many who sent him cards never learned his name—so they just addressed them to "Joe Clinic" or "the Man at the Door." Fritch retired from the clinic in April 1966 at the mandatory retirement age of 65.

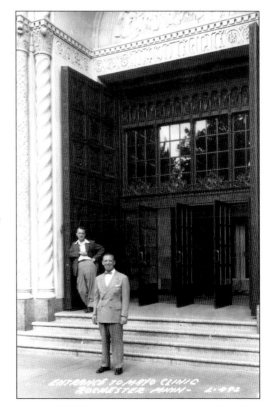

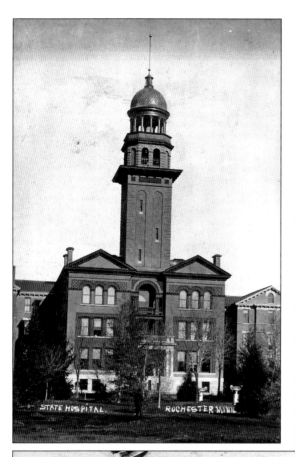

The Second Minnesota Hospital for the Insane opened in Rochester in 1879. As described in a souvenir booklet, called "the most thorough and compact Souvenir of Rochester ever put before the public," which was published by Goetting's Ten Cent Store in about 1910, "At present about 1150 persons are confined in this institution where the best of care is tendered and the results are very satisfactory. Of the number 591 are men and the remaining 559 women. Two hundred employees are maintained and do all that can be done. About $750,000 of state moneys are represented, which includes the mammoth buildings and 1000 acres of fine land. Four hundred more acres are rented for use and from the 1400 acres the entire stock of vegetables consumed is grown."

Second Minnesota Hospital for the Insane,
Rochester, Minnesota.

Property of Olmsted County Historical Society

"CHRISTMAS 1890."

Christmastide is drawing near, and with the aid of friends, we hope to make it a pleasant and happy time for the inmates of the Hospital.

WILL YOU NOT HELP US?

Any gift, large or small, that you will send to the patient here in whom you are personally interested, or a contribution to the general fund, for those who have no friends, well be gladly received.

Let all packages be sent as EARLY AS POSSIBLE, charges prepaid, to the patient for whom they are intended. In care of

ARTHUR F. KILBOURNE, Supt.

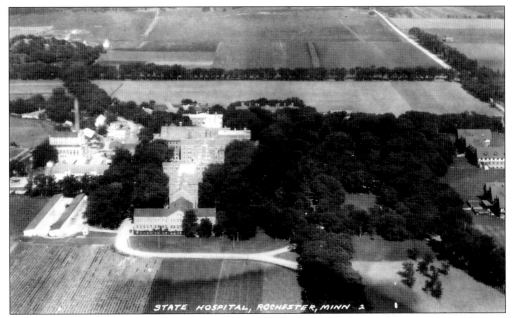

The Rochester State Hospital (as it was later called) closed in 1982 and was sold to Olmsted County for $1. In 1984, it became the site of the Federal Medical Center. Prisoners from around the country are evaluated and treated at this facility.

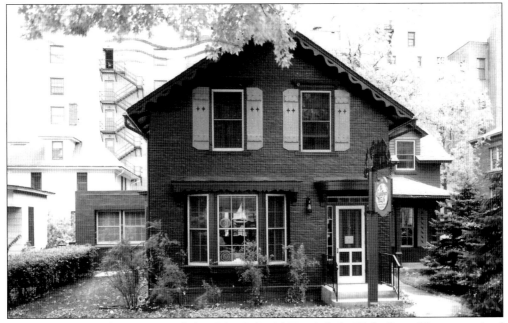

Located at 18 Second Avenue NW behind the Colonial Hospital, the Little Green House contained the Mayo Clinic's occupational therapy center. It was demolished in 1963 to make way for the Rochester Methodist Hospital.

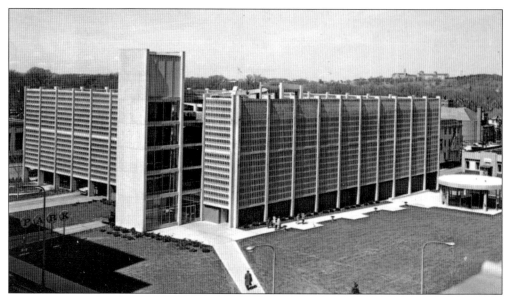

In June 1960, the Damon Hotel property was purchased by the Mayo Clinic and demolished to build the Damon Parkade. In addition to multiple floors of parking, the south end of the Damon Parkade later contained the Mayo Museum of Medicine. Under the Damon Parkade, the Curie Pavilion housed the Radiation Oncology Department. In 1998, the Damon Parkade was demolished to build the Gonda Building, and in 1999, the new Damon Parking Ramp was opened one block west.

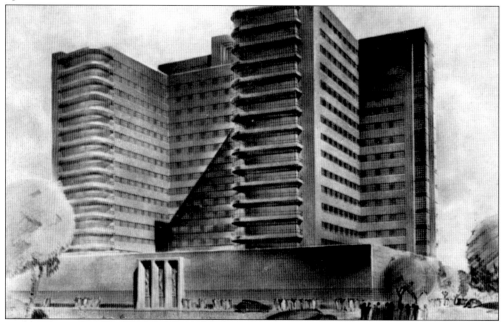

The Kahler hospital depicted in this postcard was never built. It was originally designed as a post–World War II project to help provide work for the returning American soldiers. Eventually the Kahler hospital essentially morphed into the Rochester Methodist Hospital that opened in December 1966. In 1986, both St. Marys Hospital and Rochester Methodist Hospital were integrated into the Mayo Clinic.

Six

Homes

Red Oaks, also referred to as "Willson's Castle," was built at what is now 904 West Fourth Street SW by prominent Rochester lawyer Charles C. Willson. The rear part of the house was built in 1863, and the front part, which included the tower, was completed in 1878. The house was located on a tract of land that was part of 20 acres purchased by Willson from George Head in 1857 for the sum of $125 an acre. The house and grounds occupied the entire block immediately south of College Hill (St. Marys) Park. It had 32 rooms, seven fireplaces, and a 75-foot tower. A mammoth staircase, all in black walnut, run through the center of the building up to the tower. The main part of the building was also finished in black walnut. The house was destroyed by fire on April 1, 1918. For several years, the remains of the mansion were allowed to stand, but they were finally razed.

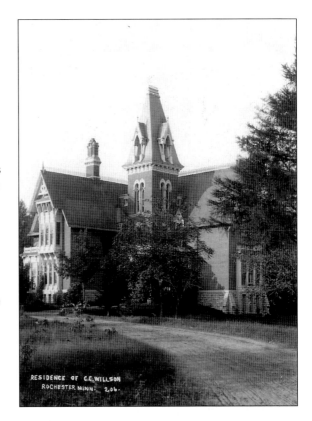

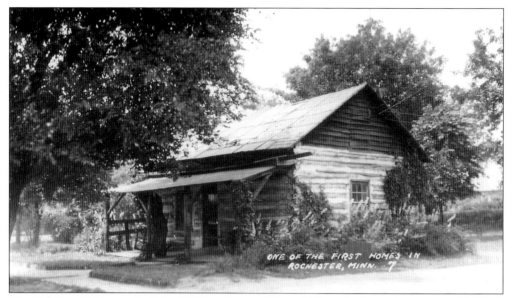

The Dee Log Cabin was built by William Dee and his neighbors in the early summer of 1862. It is the oldest surviving log cabin in Rochester. It was originally located at 428 West First Street (now Sixth Street SW). In 1911, the cabin was saved through the efforts of the Daughters of the American Revolution and moved to the newly created Mayo Park.

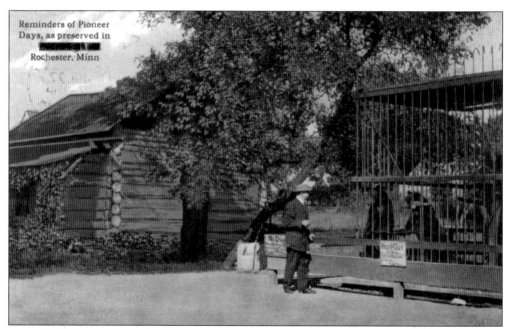

The Dee Log Cabin was relocated several times within Mayo Park. In this postcard from about 1914, it is next to the Mayo Park zoo. The zoo was eliminated when World War II made needed material for repairing the rotten cages difficult to obtain. The bears, who were mainstays in the zoo, were offered as gifts by the conservation department, but there were no takers, and in July 1942, they were shot.

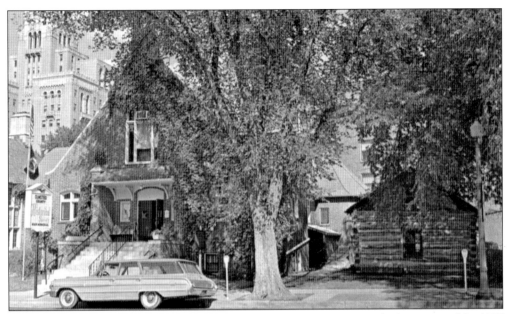

From 1940 until early 1959, the Olmsted County History Center was in the basement of the 1937 Rochester Public Library that is just barely visible at the left edge of this postcard. In 1959, the Olmsted County History Center moved next door on Third Avenue SW to what was previously the Bethel English Lutheran Church. The Dee Log Cabin was moved there from Mayo Park in 1962 by the Junior Chamber of Commerce. When the Olmsted County History Center moved to the Stoppel Farm, its present location, in November 1974, the Dee Log Cabin was moved with it. The site shown in this postcard now contains the Guggenheim Building.

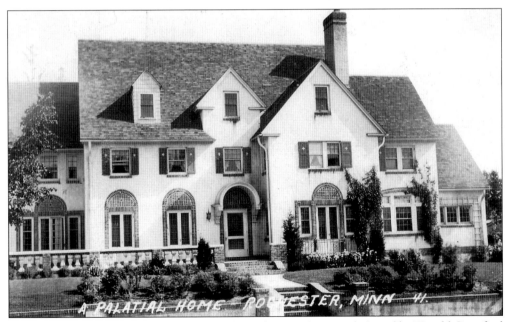

This northern Italian villa–style home at 925 Sixth Street SW was designed by Harold Crawford and built in 1923 for Dr. George B. Eusterman, a pioneer in diseases of the stomach and intestines. In 1909, he was the first physician to demonstrate the detection of cancer by use of X-rays.

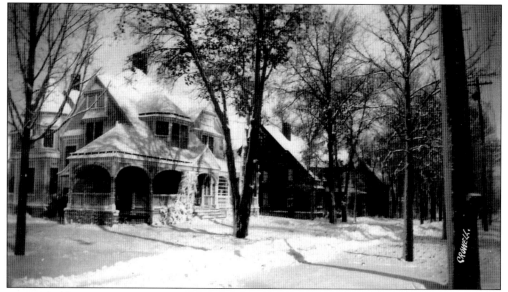

In 1887 and 1888, Dr. William J. Mayo had this home built at 427 West College Street (now Fourth Street SW). In 1918, this property was sold to the Kahler Corporation and the home was demolished to build the College Apartments.

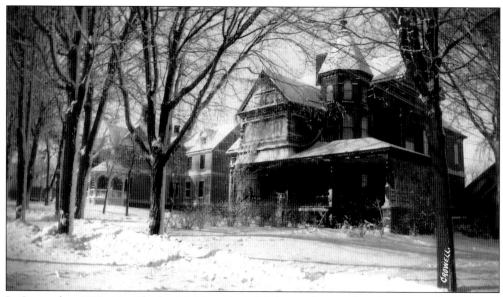

In September 1893, Dr. Charles H. Mayo had this house (later referred to as the Red House) built at 419 West College Street next door to his brother's home. For convenience, a tunnel connected the two homes. After he and his wife moved to Mayowood about 1910, the home served as the YWCA residence and later the Edith Mae Guest House. The building was razed in 1987, and the property now serves as a parking lot.

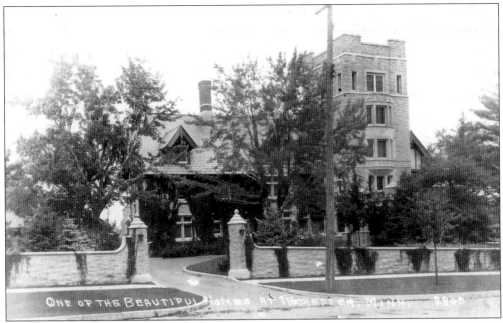

This three-story, 47-room Tudor Medieval Revival–style home at 701 Fourth Street SW was designed by Ellerbe Associates and was completed in 1918 for William and his wife, Hattie Damon Mayo. Since 1938, the home, now called the Foundation House, has been owned and maintained by the Mayo Foundation. It is used as a meeting place for the staff of the Mayo Clinic, Mayo Foundation fellows, and visiting physicians and scientists.

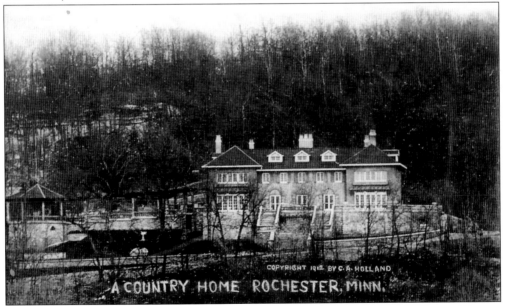

Mayowood is a 55-room Mediterranean-style mansion that was built in 1910 and 1911 for Charles and his wife, Edith Graham Mayo. Edith was the sister of Dr. Christopher Graham and the first professionally trained nurse and first nurse anesthetist at St. Marys Hospital. Charles died on May 26, 1939. Mayowood is currently owned and maintained by the History Center of Olmsted County.

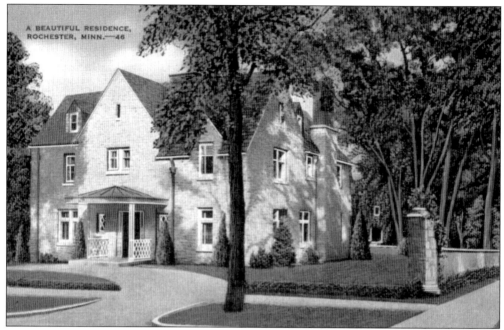

After donating their mansion to the Mayo Foundation in 1938, Dr. William J. Mayo and his wife, Hattie, moved to this new home (on the same block), which is often referred to as Hattie's House or the Damon House at 322 Eighth Avenue SW. She continued to occupy the house after his death on July 28, 1939.

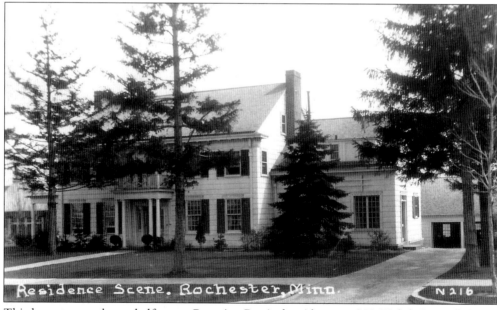

This large two-and-one-half-story Georgian Revival residence at 930 Eighth Street SW was designed by Ellerbe Associates and was built in 1925 for Dr. John J. Pemberton, who, in 1918, had been appointed attending surgeon and division head in surgery at the Mayo Clinic.

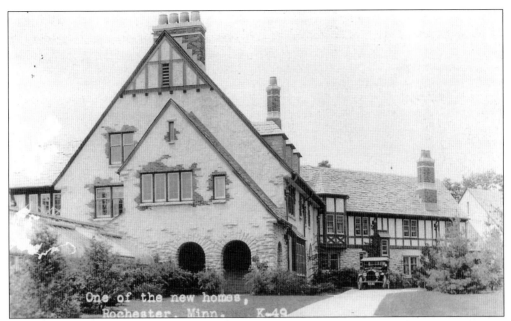

In 1917, Dr. Henry S. Plummer and his wife, Daisy, began construction of Quarry Hill, later to be known as the Plummer House. Plummer personally formulated the plans for the house, which had many innovations that were far advanced for the day, including a built-in vacuuming system. In 1924, the 65-acre estate consisted of the house, greenhouse, water tower, garage, and gazebo. Today 11 acres remain. Plummer died in 1936, and Daisy continued to live at the Plummer House until 1969, when she moved to Madonna Towers. At that time, the house and grounds were given to the Rochester Art Center. In 1972, the house and grounds were turned over to the Rochester Park and Recreation Department. Daisy died in 1976.

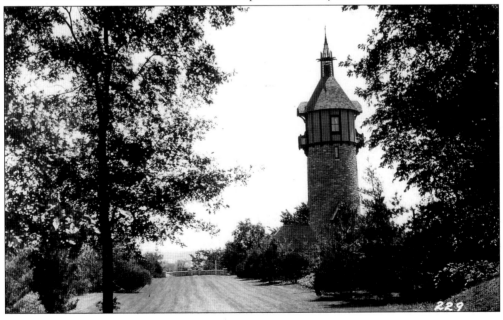

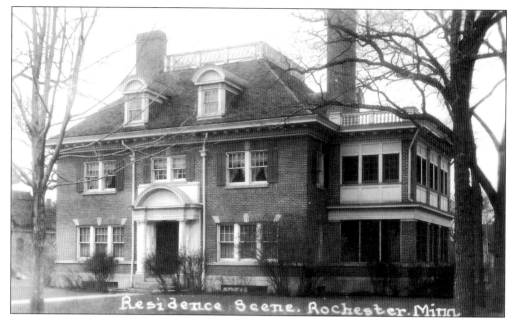

In 1912, this beautiful Georgian home at 705 Second Street SW was built as the residence for Dr. E. Starr Judd. Judd was a surgeon and one of the original partners of the early clinic of Mayo, Graham, Plummer and Judd. His wife, Helen Berkman, was a niece of Dr. William J. Mayo and Dr. Charles H. Mayo and one of the founders of the Girl Scouts in Rochester. In 1931, Judd built a new home on Twelfth Avenue SW, and in 1938, this home was purchased for the Mayo Clinic Girls Club, which formally opened on December 18, 1938.

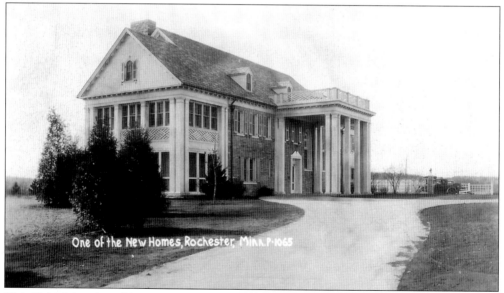

This Colonial-style residence at 721 Twelfth Avenue SW was designed by Ellerbe Associates, a Minneapolis-based group of architects, and was built for Judd in 1931. Judd died of pneumonia in 1935 at age 57. His wife continued to live in the home until 1949. Judd's brother Cornelius M. Judd was president of the Weber and Judd Drug Store and built his home at 615 Tenth Avenue SW in 1916.

Seven

PUBLIC FACILITIES

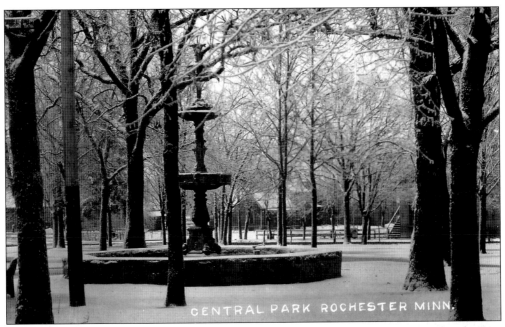

Central Park was Rochester's first public park. It consists of 1.6 acres and was donated to the City of Rochester in 1856 by William D. Lowry. In 1887, a stone fountain was added to the park. After the early 1900s, the park fell into disuse, and the fountain was dismantled. In 1928, there was debate over the legality of a proposal to build a new city hall and fire station in the park. The fountain was rebuilt in 1976 with parts salvaged from antique yards but dismantled again in about 1994 after it was damaged when a car ran into it. This postcard is dated 1908.

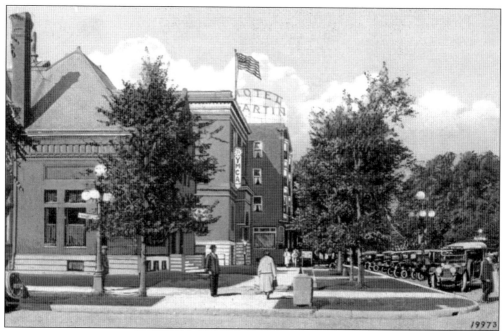

Built at the cost of $15,000 in 1898 on the southwest corner of First Avenue and Second Street SW, Rochester's first public library housed 3,000 to 9,000 books. It was sold in 1936 when the second public library, the 1937 Rochester Public Library, was completed on land provided by the Mayo Properties Association at the southeast corner of Third Avenue and Second Street SW. The 1898 Rochester Public Library was demolished in 1948 so that the First National Bank Building could be constructed.

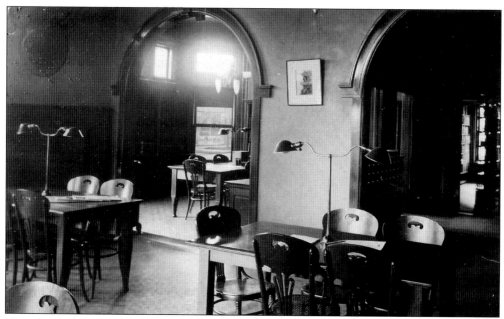

This postcard showing an interior view of the 1898 Rochester Public Library was postmarked in December 1910.

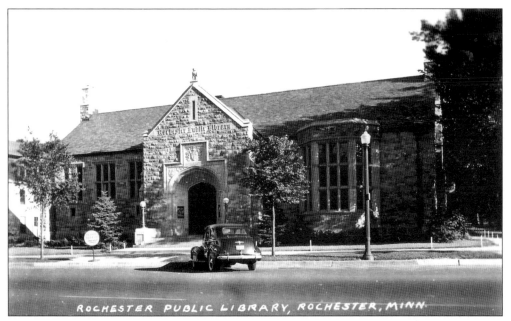

The 1937 Rochester Public Library was designed by Rochester architect Harold Crawford. After the library moved to Broadway in 1972, the Mayo Clinic purchased this building, and it is now the Mitchell Student Center for the Mayo Medical School.

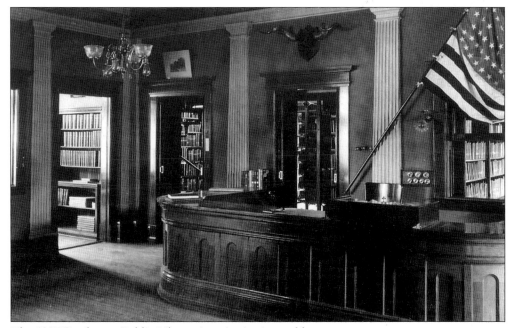

The 1937 Rochester Public Library interior is pictured here.

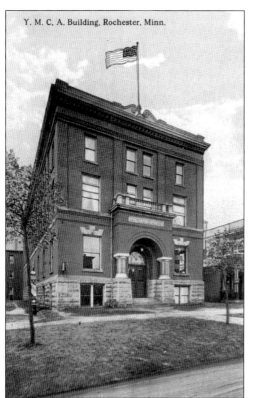

In January 1906, as part of the monthlong religious revival meeting conducted by Rev. William A. (Billy) Sunday, a total of $16,000 was pledged toward building a YMCA building. Local efforts later increased the amount raised. The YMCA formally opened on January 15, 1909, on Second Street SW just to the west of the 1898 Rochester Public Library (just east of where the Hotel Martin was built). The total cost of the site and building was $40,000, and the building contained 21 sleeping rooms. During World War I and the Great Depression, membership dropped off significantly, and in November 1932, the YMCA disbanded and the YMCA building closed. The building was sold to Mayo Properties Association in 1937 and razed in April 1938. In the late 1950s, the YMCA reorganized, and in 1964, its current building opened on First Avenue SW.

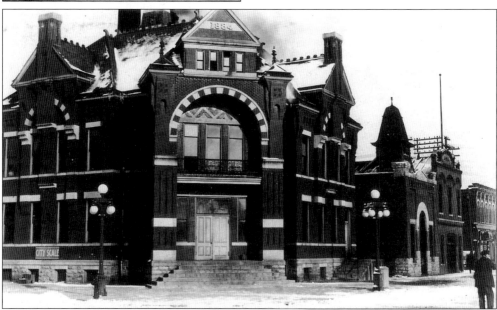

The 1884 Rochester City Hall was built for $25,000 on the northeast corner of what is now First Avenue SW and Third Street SW across the street from where Bilotti's is currently located. It was built at the insistence of Dr. William W. Mayo, who was then mayor of Rochester. At the time of its construction, it was called "one of the most imposing buildings in the state." It was demolished in July 1931 to build the 1932 Rochester City Hall, which now contains condominiums.

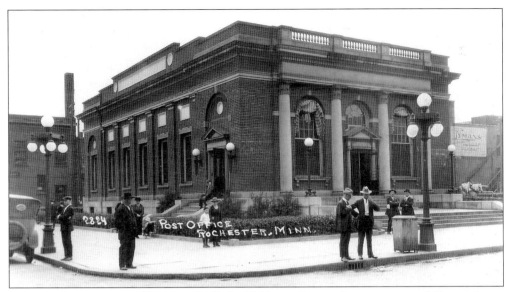

This Rochester Post Office was built in 1912 on the southeast corner of First Avenue and First Street SW. It closed in 1934 and was demolished in 1938 to build the 100 First Avenue Building.

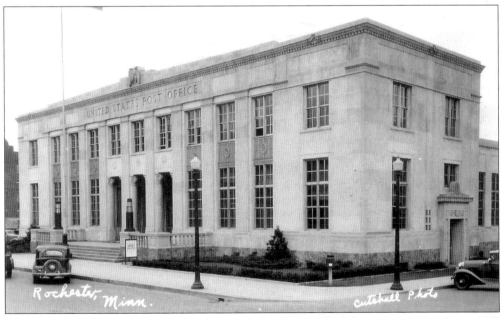

This Rochester Post Office was completed in July 1934 at Third Avenue and First Street SW, facing south. It was just east of the current St. John's Catholic Church and directly north of the Calvary Episcopal Church and the Hotel Virginia (now demolished). This Rochester Post Office was designed by Harold Crawford and constructed at a cost of $178,000. It was demolished in 1978, and this site currently contains the northern portion of the new Damon Parking Ramp. A mural from this Rochester Post Office is on display at the History Center of Olmsted County.

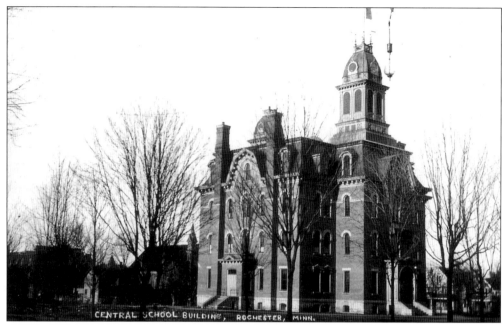

The Central School was first occupied on May 25, 1868. It originally included all the high school, intermediate, and primary school children. In 1895, because of space limitations, the high school moved to the Darling Business School building. On September 1, 1910, fire destroyed the top two floors of the Central School and its tower.

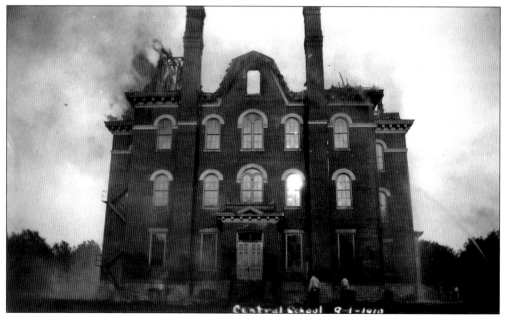

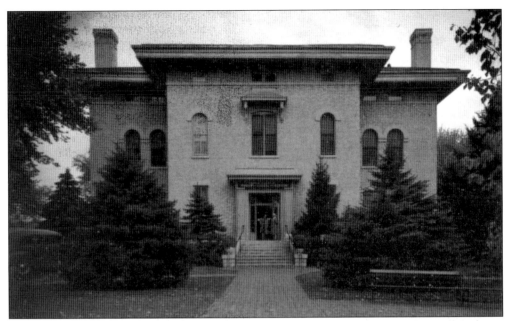

After the fire, the Central School building was reroofed and the lower two floors continued to be used as an elementary and middle school. In 1925, the Mayo Clinic purchased the building and in 1935 established the Museum of Hygiene and Medicine. In 1950, the building was demolished to build the Mayo Building.

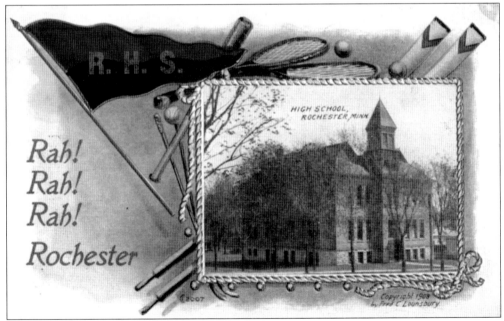

The Darling Business College building was one block west of the Central School and was originally a Methodist seminary. In 1895, because of space limitations at Central School, the city bought the Darling building and moved the high school there. In June 1910, this building was demolished to build a new Rochester High School.

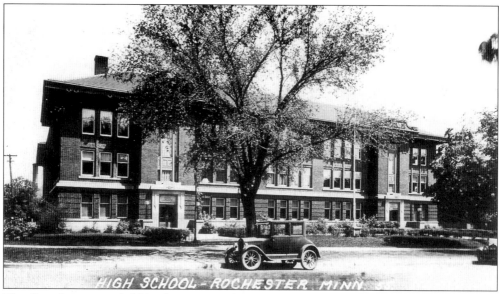

The first classes were held in the new Rochester High School on September 4, 1911. When the Rochester Junior College opened in 1915, it was originally on the second floor and later occupied the entire third floor. When Central Junior High was constructed, this building was renamed the Coffman Building. In 1958, John Marshall High School opened. In 1966, Mayo High School opened. In 1982, the Coffman Building was sold to the Mayo Clinic for $1 million. It was demolished in 1983, and the Ozmun Building was constructed on the site.

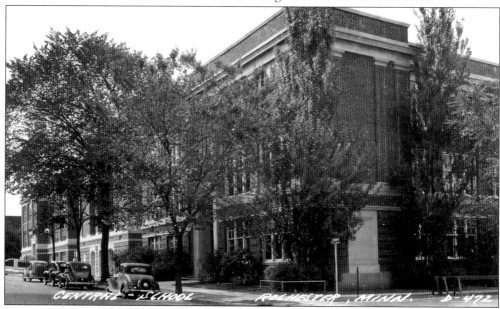

In 1927, the eastern portion of a new Central School (constructed as an elementary school) opened on the west side of Fifth Avenue SW between First Street SW and Center Street SW. It was connected by a tunnel to the high school. In October 1940, the western portion of the new Central School was constructed and dedicated as Central Junior High School. In 1981, Willow Creek Junior High opened, and the Central School was sold to Olmsted County and demolished.

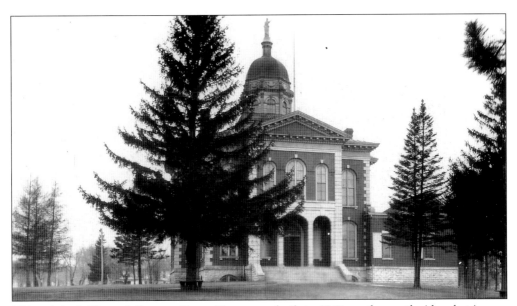

This original Olmsted County Court House was built in 1866 on the north side what is now Second Street SW. When the 1958 Olmsted County Court House was later built directly to the east, this building was demolished. The 1958 Olmsted County Court House was used until the county offices moved to the new Government Center in 1993. It was then sold to the Mayo Clinic and, after an extensive addition was constructed where the Coffman high school building had been, opened as the Ozmun Building in 1995.

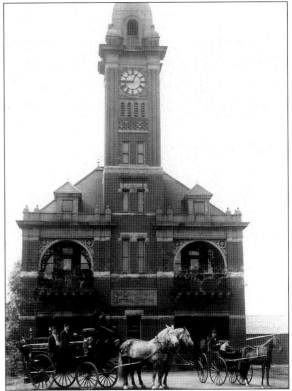

The Central Fire Station was built in 1898 in the middle of Broadway South, but since there was no bridge on Broadway over the Zumbro River at the time, this did not present a problem. Early firefighting equipment was pulled by men and later by horses. In 1912, the first motorized equipment, a 1912 American LaFrance type 12 fire truck was purchased. The fire station was razed in 1930 so that a bridge could be built and Broadway could be extended to the south. The fire pole from the 1898 Central Fire Station was reused in both the 1930 Central Fire Station and the 1995 Central Fire Station that replaced it. The Seth Thomas clock, which was purchased at a cost of $3,500 from the 1898 Central Fire Station, is now in the Mayo Civic Center clock tower.

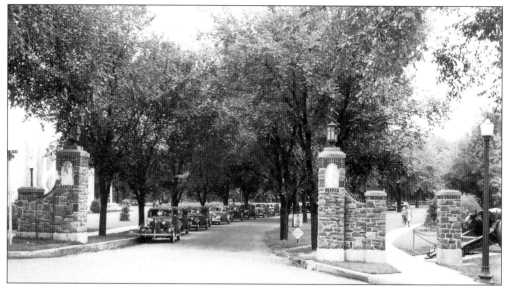

In 1904, the city council accepted $5,000 from the Mayo brothers and another $1,000 from John R. Cook for the purchase of the original 11 acres of land that later became Mayo Park. Another 16 acres were added later.

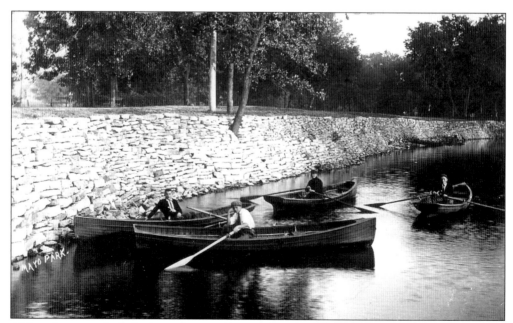

Although not particularly deep, the Zumbro River has always played a major part in the life of Mayo Park. In addition to boating, in 1907, a 48-by-28-foot "modern bathhouse" was erected with 33 dressing rooms for men and 25 for women.

The Mayo Park Rest House at 314 East Fifth Street (now Center Street) was originally the home of J. A. Leonard, a prominent citizen of Rochester who wrote an extensive history of Rochester and Olmsted County that was published posthumously in 1910. The Mayo Park Rest House was a place where the wives of farmers and others could go to freshen up while their husbands shopped for farm supplies.

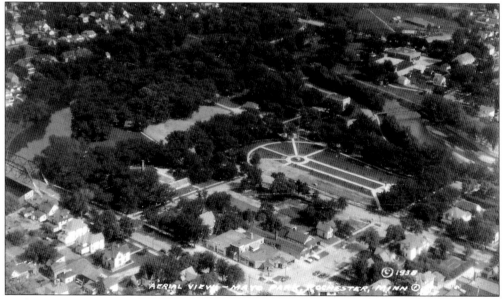

In this 1938 aerial view of Mayo Park looking southeast, perhaps one of the most interesting things to notice is that the Mayo Civic Auditorium does not yet exist and there are stores on the southeast corner of Center Street and Fourth Avenue SW where the Rochester Civic Theater now stands. The Rochester City Council purchased the last three commercial properties on this corner in 1965. The Mayo Memorial in the park was dedicated on September 22, 1952, and relocated in 1984. The Mayo Civic Auditorium was built in 1939.

Harold Cooke, a native of Rochester, began his musical career as a drummer in Rochester's first boys' band, organized by his father. He later studied music at the New England Conservatory of Music in Boston, and also in New York and Vienna, and earned his master's degree in music education from the MacPhail School of Music in Minneapolis. Cooke cofounded the Rochester Symphony in 1920 with his brother Glenn, the Rochester Male Chorus in 1930, and the Rochester Boychoir in 1963. Through his many musical endeavors, he came to be known as "Mr. Music, Rochester, U.S.A." In addition to serving as executive director of Rochester Civic Music for 27 years, he was the musical director of the Rochester Symphony Orchestra, the

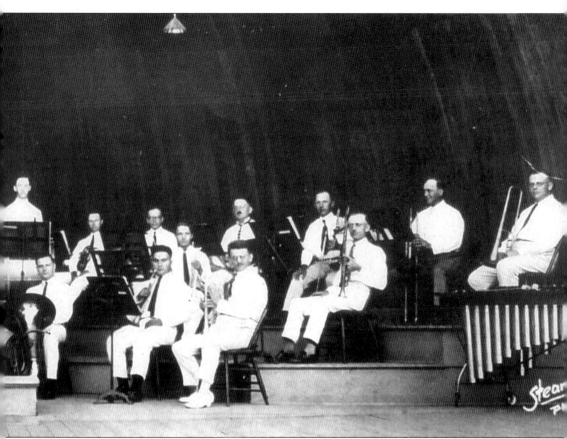

Rochester Park Band, the Methodist-Kahler Student Nurses' Glee Club, the St. Marys Student Nurses' Glee Club, the Mayo Clinic Women's Chorus, and the Rochester Oratorio Society. Cooke died on October 11, 1974, at the age of 80. The Mayo Park Bandstand was built in 1915 at a cost of $18,500. It was designed by the Ellerbe and Round architectural firm and was one of the first bandstands built in the country. Minneapolis later built a bandstand designed after the one in Rochester. The Mayo Park Bandstand was demolished about 1950 to make way for the Mayo Memorial.

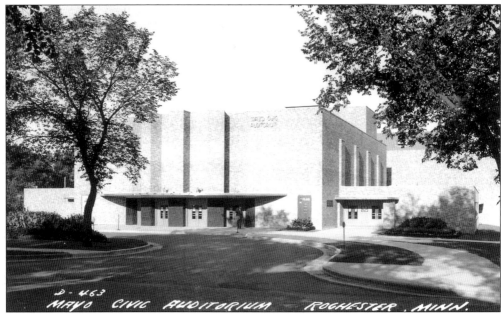

The Mayo Civic Auditorium was constructed in Mayo Park in large part because of a $450,000 gift from Dr. Charles H. Mayo and the Mayo Association. At the time of its opening in 1939, it was described by city fathers as "the finest auditorium ensemble of its size in the world." The original auditorium consisted of what is now called Presentation Hall and the auditorium. The auditorium contained ice-making machinery and could be used for hockey, recreational ice-skating, and occasional performances by the Ice Capades. In 1986, an $18.5 million civic center addition to the Mayo Civic Auditorium, including Taylor Arena, was dedicated. The Exhibition Hall and the North Lobby were added in 2001, and the new Rochester Art Center was added in 2003. The civic center complex is managed by the Rochester Park and Recreation Department.

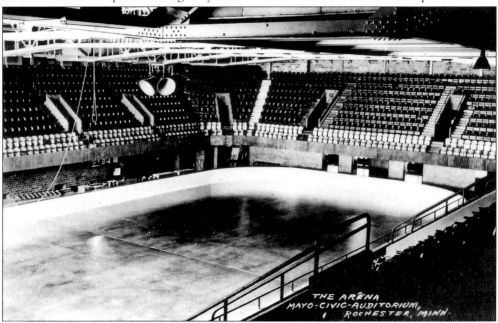

Baseball has long been a popular sport in Rochester. Dr. William J. Mayo and Dr. Charles H. Mayo donated the land for Mayo Field on East Center Street in 1910. The 2,200-seat grandstand was constructed in 1951. In addition to high school and community college teams, Rochester has had a number of regional baseball teams, including the Queens, the Aces, the Bugs, and the Athletics. Currently the Royals and the Honkers play at Mayo Field, and the Roosters and the Hens play vintage baseball at Schmitt Field at the History Center of Olmsted County.

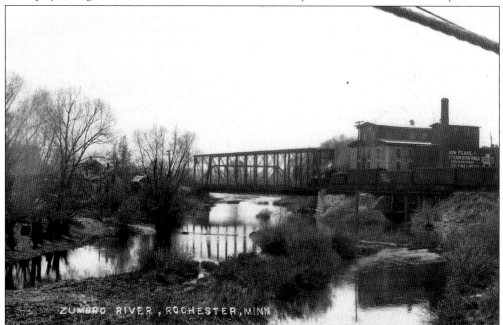

As tame as the Zumbro River normally is, it is hard to believe that Rochester has repeatedly suffered from extremely damaging floods. In 1978, a major Rochester flood caused $60 million in damages. Previous major floods occurred in 1908 and 1951 with lesser floods in 1859, 1866, 1882, 1925, 1962, and 1965. In 1995, the $155 million flood control project was dedicated.

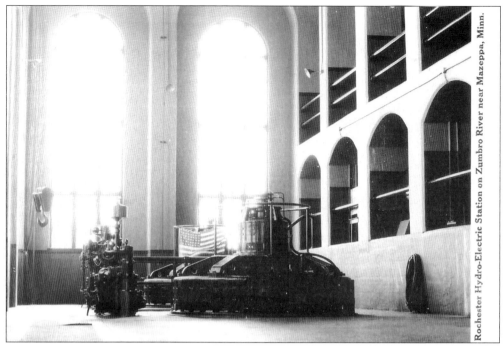

The Rochester Hydro-Electric Station is located on the Zumbro River, 17 miles from Rochester in Mazeppa, and started operating in November 1919. Prior to the hydroelectric station, all Rochester electricity was generated using steam. It was originally thought that once the station was completed, the steam plant would no longer be necessary. In fact, due to the increased demands of an ever-growing city, it was only a matter of months before the steam plant was back in operation in addition to the hydroelectric station.

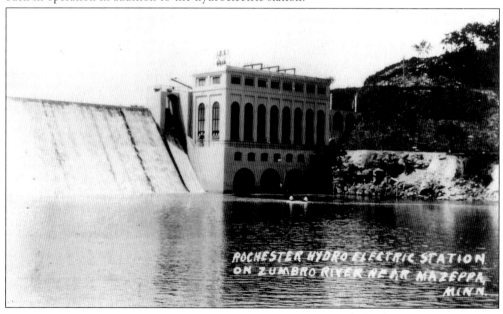

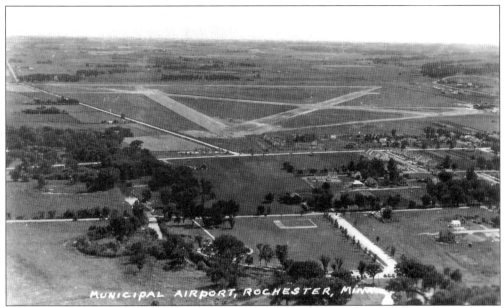

This aerial view looking south shows Lobb Field, Rochester's first commercial airfield, which opened in 1928 and was east of the present-day county fairgrounds. That is Eleventh Avenue SE coming in from the upper left-hand corner of the photograph and current-day Highway 14 that it joins in the center. Slatterly Park is in the foreground. The airport terminal building below is at the extreme right of the image above. It was not until September 1952 that the airport was officially named Lobb Field after Alfred J. Lobb, who was credited as being chiefly responsible for its development. The first airmail service was instituted in Rochester in March 1939. The current Rochester airport opened in 1960 and became the Rochester International Airport in 1995.

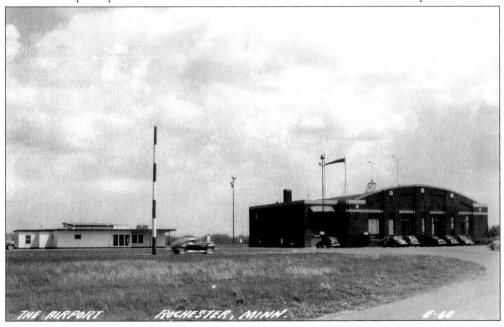

Fourth Street SW was originally called College Street and St. Marys Park was originally called College Hill Park. The stairs shown in this postcard led from Second Street SW (Zumbro Street) up to College Hill Park. The middle section of the stairway still exists behind a fence. The top and bottom sections have been removed.

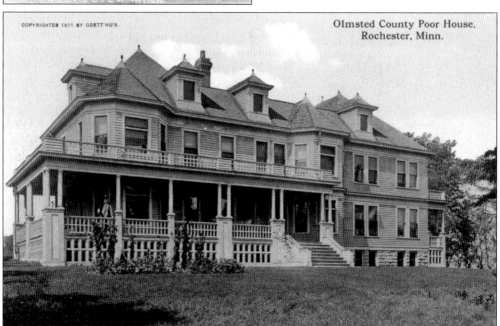

The Olmsted County Poor House was located just south of the old airport (Lobb Field). It was constructed in 1896 and sold to Mayo Properties in 1943. In 1947, it was purchased by a private individual for use as an apartment house.

Eight
BUSINESSES

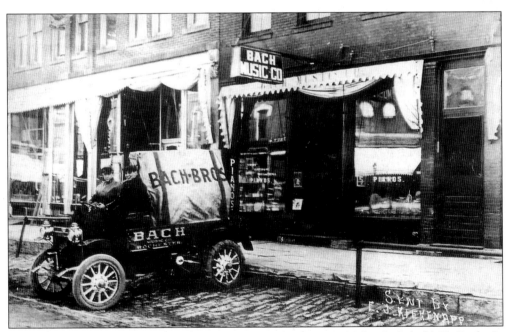

The Bach Music Company was founded in Owatonna in 1892 by Reinhold H. Bach. In 1906, Bach's younger brother Adolph opened a Bach Music Company store in Rochester at 222 Broadway South. In 1946, the store moved to 315 Broadway South and grew at that location to include three storefronts with teaching studios and a large auditorium. In 1971, the business was purchased by the Schmitt Music Company. An interesting side note is that Adolph Bach was a seventh-generation descendant of Johann Sebastian Bach, composer and member of the musical trinity, Beethoven, Brahms, and Bach. Adolph was a talented musician in his own right.

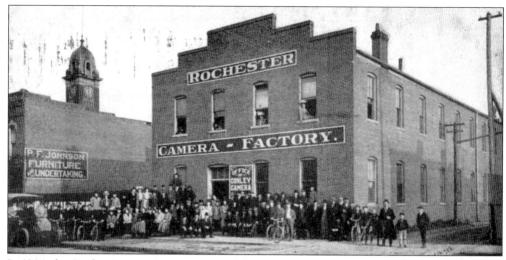

In 1904, the Conley Camera Company moved from Spring Valley to this building at 12–14 College Street (now Fourth Street SW). Legend has it that Conley's largest customer, Sears, Roebuck and Company, wanted to be able to say that the cameras were made in Rochester since Kodak was located in Rochester, New York. By 1908, Conley had outgrown this two-story, 44-by-132-foot building and bought land for a new, larger camera factory at 501 First Avenue NW. The building shown in this postcard was later occupied by Maas and McAndrew Plumbing and then the Reichert Appliance Store. It is now home to the Masque Children's Theatre.

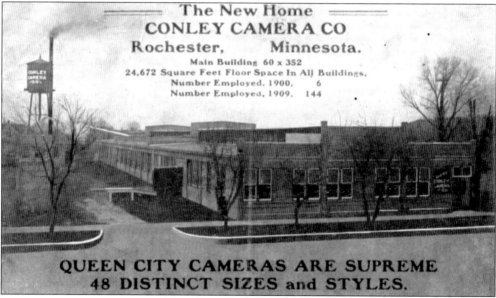

In 1909, 47 percent of the Conley Camera Company was sold to Sears, Roebuck and Company to raise money for the new 60-by-300-foot facility. It was the first poured-concrete building constructed in southern Minnesota. In 1910, Sears bought the remaining 53 percent of the camera company, and it became its second wholly owned factory. In 1916, Conley began producing spring-wound phonographs. In 1927, Conley discontinued camera production as competition sold cameras at cost or below to make profit on film. In 1940, Glen M. Waters purchased the assets of Conley and formed the Waters Conley Company, which manufactured milk pasteurizers and medical equipment. In 1954, the medical division became the Waters Corporation.

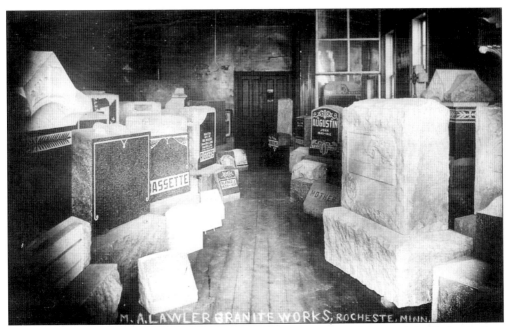

The Lawler Granite Works was owned by Michael A Lawler and was originally located on First Street NW between First Avenue NW and Broadway. By 1921, it had moved to 23 North Broadway. Lawler died on December 23, 1923.

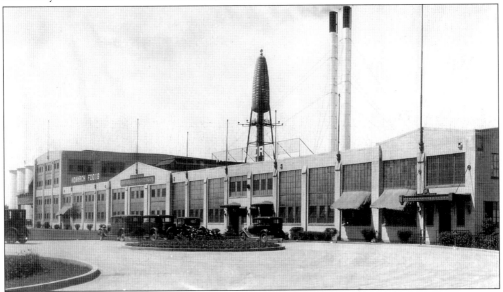

Reid, Murdoch, and Company of Chicago opened its new canning factory at Third Avenue and Twelfth Street SE in 1929. By 1943, it had the second-largest farm system in the United States, operating 60 farms with 10,000 acres of tillable land under long-term lease to produce peas, sweet corn, and lima beans for the Monarch label. In 1948, Libby McNeil and Libby acquired the Rochester plant from Reid, Murdoch, and Company. In 1982, Seneca Foods acquired the Libby's canned vegetable operation. The landmark corncob water tower is 151 feet tall and is a functioning water tower that holds 50,000 gallons of water. It was built in 1931 and contains a biologically correct number of rows and kernels.

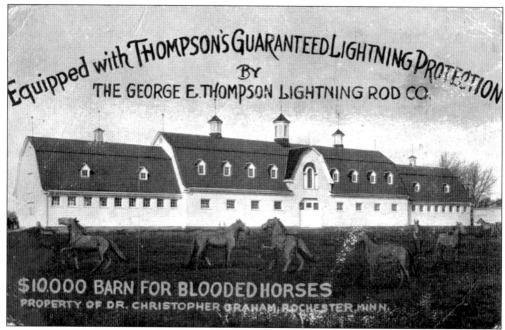

Dr. Christopher Graham was one of the original partners in the early clinic of Mayo, Graham, Plummer and Judd. He was also the brother of Dr. Charles H. Mayo's wife, Edith Graham Mayo. Before becoming a medical doctor, Graham had been a veterinarian, and he retained a love of horses. In 1916, Graham hired Harold Crawford to design and oversee the building of this impressive horse barn in the 1100 block of Broadway South where he bred and raised champion Clydesdale draft horses. In 1919, Graham granted the Olmsted County Fair Association a permanent lease to the land that now constitutes the Olmsted County Fairgrounds.

STORM and BAD ROADS have caused a SURPLUS of CHICKS at the Rochester Chick Hatchery.

We must move these 3 & 4 week old Chicks at once.

Here is your chance to get a real bargain. These reduced prices are good for one week only, so please hurry.

"Buy me, I'll earn money for you."

Rochester Chick Hatchery

The Rochester Chick Hatchery was started in 1924 by Andrew Urness in one room of Graham's horse barn located at 1001 First Avenue SE. The business grew and expanded at that location and soon became one of the largest operations of its kind in the nation. In 1950, the company built a large breeding plant on 48 acres in southeast Rochester called Urness Poultry Farm. Urness retired in 1960, and the business was sold several times but remained in the original location until about 1979, when it was relocated to the east side of Broadway South across from the old Fleet Farm.

This great old postcard from about 1919 shows the truck and family of Jacob Kunz, who, with his wife, Lizzie, operated the Jacob Kunz General Hauling business at 109–111 North Broadway. In 1921, the Kunz family moved to Douglas. Judging by the size of his family, it appears that Kunz was uniquely suited for the furniture-moving business.

The original Rochester Masonic Temple building was constructed in 1900 on the northwest corner of what is now First Avenue and Second Street SW. The Mayo medical offices occupied the second floor of the Rochester Masonic Temple from 1901 until the 1914 Clinic Building opened.

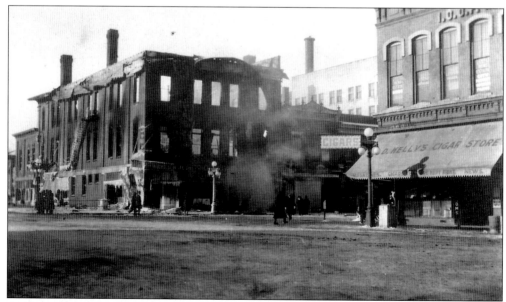

On January 17, 1916, an extensive fire gutted the building.

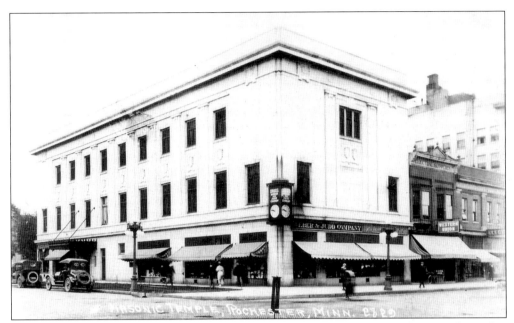

The second Rochester Masonic Temple building was built on the same site in 1917. The Weber and Judd Drug Store and Soda Fountain was a popular tenant on the first floor of the new building. This rebuilt Rochester Masonic Temple was ultimately demolished in 1987 as part of the Galleria Mall project.

This gray building at 212 First Avenue SW features a green tile roof and housed the Commercial Club, a civic and commerce association and precursor to the Rochester Area Chamber of Commerce. Current occupants of this building include the City Market and the Olive Juice Photography Studio.

Despite the 1910 date on this building at 324 Broadway South, it is actually much older. From 1891 (at the latest) until at least 1904, the C. H. Morrill and Son wholesale grocer occupied the building. In 1909, L. J. Smith purchased the building and operated the City Bakery there until 1912 when he renamed it the L. J. Smith Bakery, which it remained until 1914. When Smith built "a commodious addition" to the rear and a put a new front on the store in 1910, he placed the date 1910 on the building to show how modern it was. Later occupants included the Joseph Devlin Harness Shop from 1913 until 1935, several cafés, and several billiard parlors. The building is currently the home of the Fagan Photography Studio.

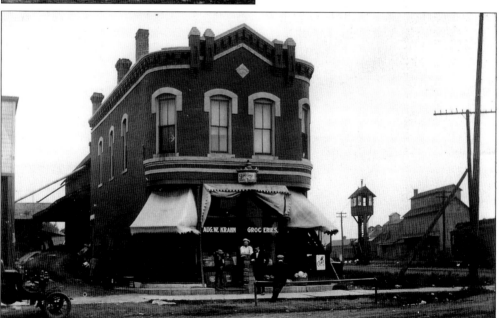

Prior to 1914, the August H. Krahn Grocery Store was located at 315–317 North Main Street (now First Avenue NW) and specialized in "Staples and Fancy Groceries, Fine Teas and Coffee." This was later the site of the North Star Bar and now contains the American Legion Post 92.

LeRoy "Shepherd of the Sandhills" Shane was a large wholesaler and retailer of novelties and Rochester postcards. He had a large souvenir shop at 7 Second Street SE from 1943 until 1952. In 1952, the company moved to larger quarters at 27 Sixteenth Street NE near Silver Lake. Shane achieved national recognition for manufacturing Big Chief Indian tom-toms starting in the mid-1940s and Davy Crockett powder horns and vests in the mid-1950s. Shane's tom-toms were originally made by a family of Native Americans during World War II from large empty cans and inner tubes. By 1954, the 7 Second Street SE location had been absorbed into a new O'Connors Menswear store (124 Broadway South), which in 1958 became Arnolds Menswear. This site is now occupied by the Radisson Hotel. By 1969, LeRoy Shane (wholesale) had been renamed Fairway-Shane.

Clarence G. Stearns operated his Rochester photography studio for more than 25 years from about 1910 into the 1930s. For at least part of the 25 years, the studio was located on First Avenue SW behind the Kahler Hotel, which, at that time, only occupied the west half of the block. This postcard was postmarked in November 1931. The post office referred to by the postcard is the 1912 Rochester Post Office that was located where the 100 First Avenue Building is now. Upon retirement, Stearns sold his studio to Gilbert Woodcock of Albia, Iowa.

The Schuster Brewery was located at First Avenue SW and Fifth Street SW. In 1857 and 1858, it was the Union Brewery. In 1865, Henry Schuster purchased an interest in the Union Brewery, and it became part of the firm of Schuster and Joest. The brewery produced beer prior to Prohibition and near beer until closing in 1921. After the brewery closed, the building was occupied by the Rochester Dairy, which later moved to the east side of Broadway and became Associated Milk Producers Inc. (AMPI). Ironically in 1958, the property was purchased by the Schuster Realty Company, and the building was demolished.

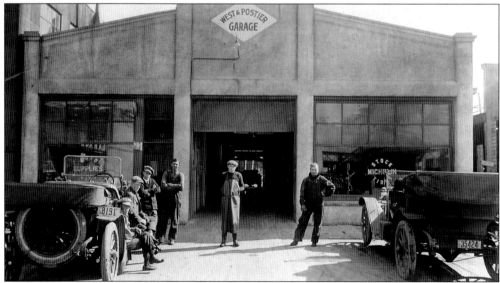

The Postier name was associated with the automobile industry in Rochester and specifically General Motors for over 70 years. In 1912, Carl West and Henry J. Postier opened the West and Postier Garage at what is now 316–318 First Avenue SW. By 1926, the Kitzman, West and Postier Buick dealership was located at 419–423 First Avenue SW. In 1981, the Postier-Eggers dealership moved to the corner of Thirty-seventh Street and Highway 63 North and the First Avenue building was demolished for the construction of an office building for Reliance Federal Savings and Loan.

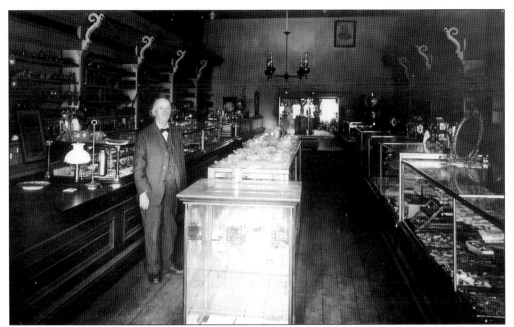

Eleazor Damon's jewelry store was located at 217 Broadway South. Damon, who built the two-story brick building in 1858 two years after coming to Rochester, was the father of Hattie Damon Mayo, the wife of Dr. William J. Mayo. Damon retired in 1892 and sold the business to H. Luce. The gentleman in the postcard is not identified, but he is not Damon.

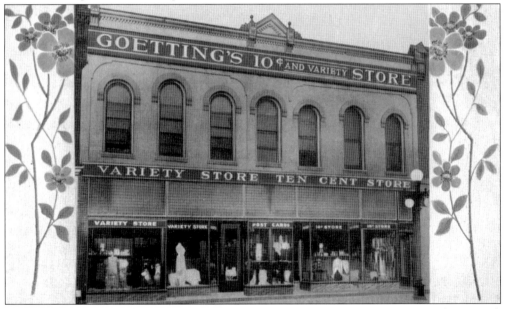

From 1909 until about 1916, the Goetting's 10¢ and Variety Store at 214–216 Broadway South claimed to be "the largest ten cent and variety store in the West," with "the largest line of post cards and souvenirs in Rochester" and "a specialty of ten cent goods, drug sundries, underwear, hosiery and notions." From 1917 until about 1946, F. W. Woolworth is listed at this address. By 1950, Woolworth's had built its new store and moved across the street to the former Cook Hotel site.

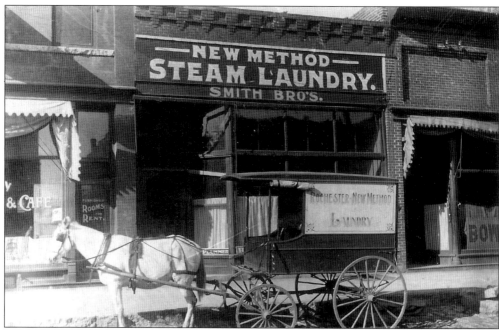

In 1900 and 1904, the New Method Steam Laundry was owned by the Smith brothers and was located at 223 Broadway South. By 1909, it had moved to 11 Broadway South.

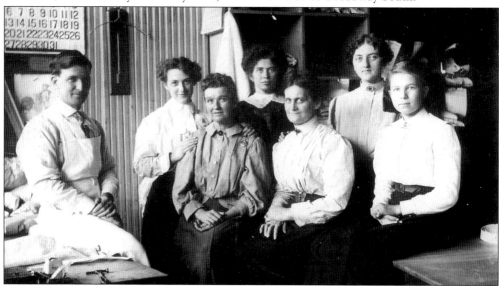

In 1905, the Rochester Steam Laundry occupied the site that was later to contain the Hotel Zumbro at 105–107 South Main Street (now First Avenue). This laundry was established by Mary I. O'Rourke. She sold it to Mack and Douglass, who operated it in 1904. Edd O. Plummer took possession in 1905, and upon his death in 1907, Mrs. Plummer took over management. In 1908, she moved the business to a building at 11 Broadway South that she purchased. She operated the business there until her death in 1952 at age 77. The laundry closed in 1953. An advertisement in the 1909–1910 city directory described the Rochester Steam Laundry as the "Only First Class Laundry in the City," which leads one to wonder how the other two laundries felt about that claim.

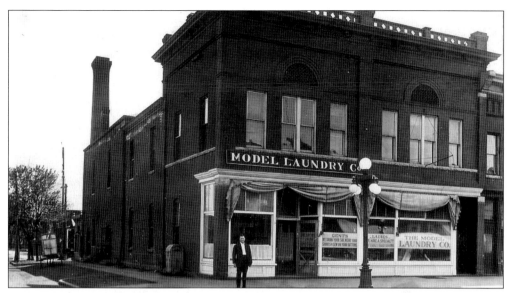

In 1909 and 1910, the Model Laundry, run by proprietor John H. Kahler, was located at 15 North Broadway. From 1913 until 1929, the laundry was located at 2–4 Broadway South on the southeast corner of Broadway and Center Street. In 1921, it was advertised as "the Soft Water Laundry." In 1929, the new Model Laundry Building at 219 First Avenue SW, the former site of the Pierce House, was completed. The building on Broadway South (above) was later renovated into a Sears, Roebuck and Company store, which opened in 1936 and moved to Apache Mall in 1963. More recently, this was the site of C. J.'s Lounge. This building was demolished in December 2007.

In 1888, Mary A. Scott and Clara Everstine opened their needle craft and corset shop in a small building later demolished to build the Brackenridge Building. From 1896 until 1912, the business was located on the first floor of the IOOF Building, which was also referred to as the "old post office building," located at 23 Second Street SW. In 1912, they moved to the Hotel Zumbro building at 109 South Main Street (now First Avenue SW) and were there until about 1931. This postcard is dated 1913.

This Consumers Beef and Provision Company's Sanitary Market postcard is something of an enigma. According to the card's identification number and the records of the Curt Teich postcard company, this postcard was produced in 1916, but there is no other evidence this company ever existed. In 1931, the city directory lists a Consumers' Meat and Grocery Company at 822 North Broadway, but there is nothing to tie the two companies together. It is possible that this postcard was a salesman sample for a fictitious business.

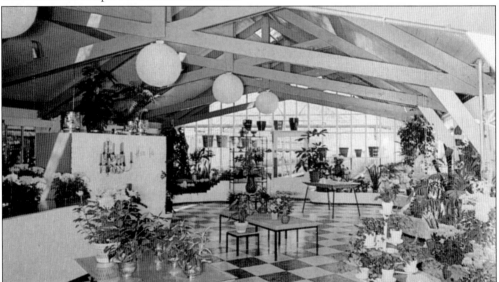

The Holm and Olson nursery business was established in St. Paul by E. P. Holm and O. J. Olson in 1895. In 1927, Holm and Olson sent Harald Thompson to Rochester to start a new branch here. By 1946, the Rochester greenhouse at 810 Eleventh Avenue NW covered 100,000 square feet and was among the largest in the Midwest. Holm and Olson also built the Lexington Building at 1021 Seventh Street NW. Upon Thompson's death in 1957, Robert D. Holm, grandson of the cofounder, came from St. Paul to take over the management. About 1972, the Rochester Holm and Olson stores were purchased by Bachmann's.

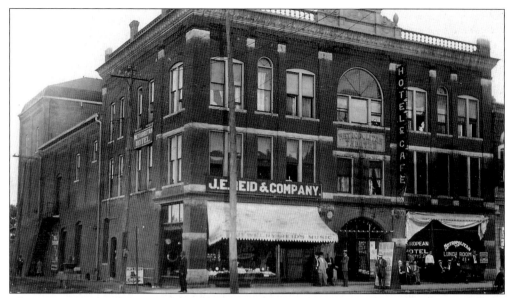

The Metropolitan Theater was built in 1901 at 102 Broadway South SE on the southeast corner of Broadway at First Street SE. Hailed at the time as "one of the prettiest, most complete and tasty theaters in the northwest," it contained 800 seats plus eight private boxes and had a 33-by-65-foot stage. The Metropolitan Theater was demolished in 1937 to erect the Montgomery Ward store, which now contains the Sterling State Bank, the downtown post office, and Piper Jaffray.

The 100 First Avenue Building was completed around 1939 after the 1912 Rochester Post Office was demolished in 1938. Fanny Farmer occupied 104 First Avenue SW in the 100 First Avenue Building from about 1940 until about 1976. In 1979, Fanny Farmer moved to the Kahler Hotel. A second Fanny Farmer candy shop operated out of the Crossroads Shopping Center from 1965 until 1976. This site, on the corner of the Peace Plaza, is currently occupied by the O and B Shoes store.

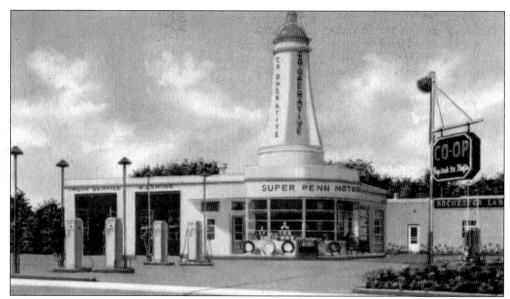

In 1940, the Cooperative Oil Company of Olmsted County completed this all-steel structure that was designed by Harold Crawford at 601 Broadway South. During its first eight years, the station stayed open 24 hours a day and employed up to 13 employees. In 1969, the Cooperative Oil Company of Olmsted County merged with Dodge County Service Company and became Greenway Cooperative. This building was demolished in 1977 to make room for the construction of a Burger King that is now a Mexican restaurant.

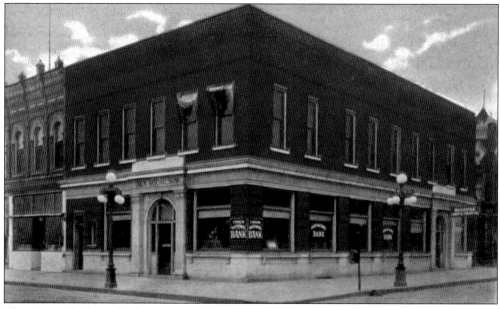

The Union Block was built in 1867 on the southwest corner of what is now Broadway and Third Street SW and originally contained the Union Savings Bank. In 1873, the bank secured the necessary credentials to operate as the Union National Bank. After the bank moved to Second Street in 1956, this building served as the site of the Rochester Savings and Loan Association, the Reliance Federal Savings and Loan, and later Wong's Chinese restaurant. This building now houses the Sontes Restaurant.

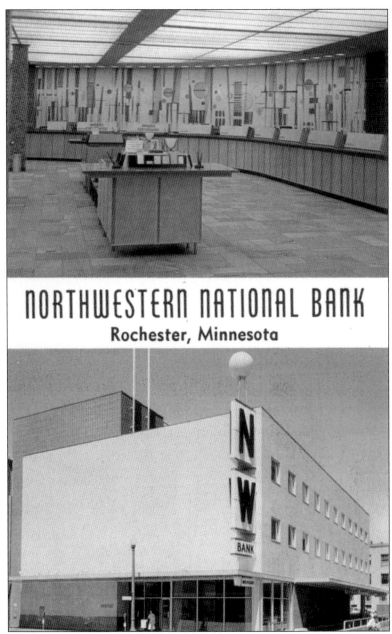

In November 1946, the Northwest Bancorporation purchased Union National Bank of Rochester, which was located on Broadway South at the time. The Brackenridge Building at 15–23 Second Street SW was demolished in 1956 so that this building could be built. On March 1, 1956, the name of the Union National Bank of Rochester was changed to the Northwestern National Bank of Rochester. In 1982, Northwestern National Bank of Rochester was rebranded Norwest Bank Rochester. In 1998, the Norwest Corporation merged with Wells Fargo and Company and adopted its 148-year-old name. The "weatherball" above the NW Bank sign displayed the weather forecast according to the following poem: "Weatherball red as fire, Temperature is going higher. Weatherball emerald green, Forecast says no change foreseen. Weatherball white as snow, Down the temperature will go. Weatherball blinks in agitation, Forecast says precipitation."

In 1935, Greg Gentling started KROC as a radio station in the Hotel Martin. In 1940, KROC moved to the 100 First Avenue Building (seen below). When Gentling died in 1942, his son G. David Gentling took over operation of the station. In July 1953, KROC-TV (channel 10) was added. In November 1966, KROC-TV moved to 601 First Avenue SW. In 1976, KROC-TV was sold to Quincy Newspapers of Quincy, Illinois, and renamed KTTC-TV. According to newspaper accounts at the time, KTTC stood for Tri-state Television Coverage.

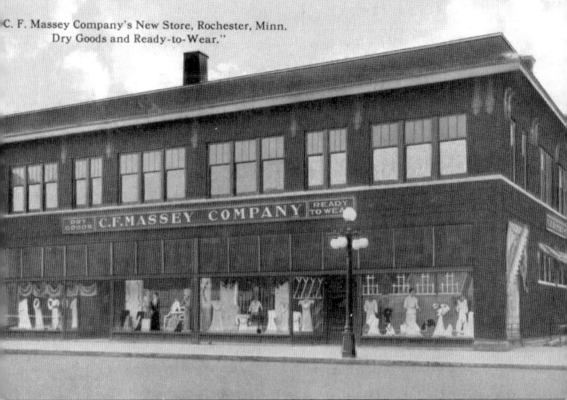

"C. F. Massey Company's New Store, Rochester, Minn. Dry Goods and Ready-to-Wear."

In 1875, C. F. Massey moved to Rochester to succeed his uncle F. W. Andrews as agent in charge of a dry goods store purchased in 1856 and owned by John R. Cook. In 1880, Massey bought out Cook. In 1890, Massey entered a partnership with S. C. Furlow, and the store was renamed Massey and Company after being called F. W. Andrews Dry Goods. From 1883 until 1901 (when they moved to the Rochester Masonic Temple building), the Mayo medical offices were on the second floor of this building. In 1911, the store was incorporated under the name C. F. Massey Company. Massey's was in the Cook Hotel building from about 1869 until 1912, when it moved to this Second Street location at the southeast corner of Second Street SW and First Avenue. In 1952, the store was renovated, and a granite exterior was added. In 1965, Alan H. Rich purchased Massey's. In 1977, Rich sold Massey's to Braun's Fashion of Minneapolis. In 1991, Massey's was renamed Second Street Shops. In 1996, Second Street Shops closed, largely a victim of Apache Mall. In 1998, the Mayo Clinic leased the building, and it now contains six Mayo Clinic departments and the HGA Architecture firm.

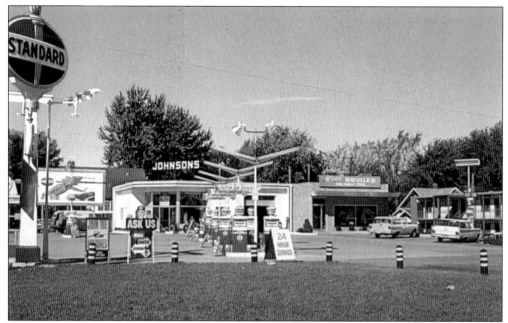

Located at the "Junction Highways 14 and 52 North," this postcard from the 1960s describes Johnson's Standard service station as the "Largest Standard Station in the Northwest," with the "Finest Ladies' Lounge in Southern Minnesota" and a "Café & Motel on Site." Wade's Broiler Restaurant is on the right of the service station.

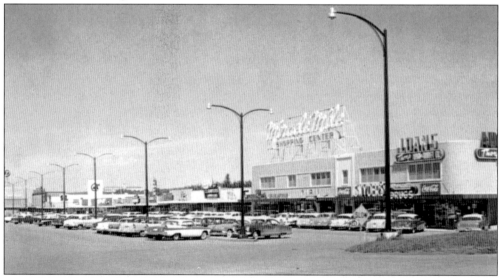

When the Miracle Mile Shopping Center opened in 1952, it was advertised as "the first shopping mall in the state outside of the Twin Cities." (Crossroads Shopping Center opened in Rochester in 1962, and Apache Mall opened in October 1969.) When the Miracle Mile Shopping Center opened, the three largest stores in the mall were a Red Owl Supermarket, "the largest supermarket in the Midwest"; Donaldson's Department Store (later Carson Pirie Scott); and Niesner's. On February 21, 1971, a fire destroyed the south end of the mall and the second floor. The Miracle Mile Shopping Center was originally on Highway 52, with direct highway access. The Miracle Mile Shopping Center was recently renovated.

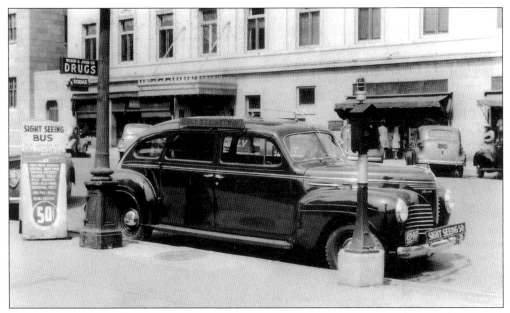

This postcard shows the McGoon's sightseeing bus parked on Second Street SW in about 1940. The building in the background is the south side of the Rochester Masonic Temple that contains the Weber and Judd Drug Store and Soda Fountain. The southeast corner of the Plummer Building is at the extreme upper left. Howard A. McGoon operated his tour service from the late 1920s until at least the early 1940s. On the cover of the August 17, 1930, issue of the *Know Rochester* publication, his tour bus is a stretch Packard limousine. Gooney's Comedy Club in the old Olmsted County Bank building is named after McGoon.

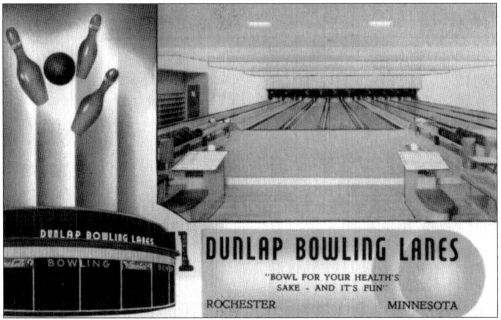

The Dunlap Bowling Lanes were located at 412–418 First Avenue SW from 1940 until 1944. Z. D. Dunlap was the manager. He was also the president and general manager of the Motor Sales and Service Company. By 1954, Universal Motors Company occupied this location.

The Hemp Antique Museum was home to "40 Antique Cars & Horse Drawn Vehicles from Bygone Days" and also quite a few antique tractors. It was located "5 miles straight west of the Mayo Clinic past Saint Marys Hospital on beautiful Country Club Road (County 34/Second St SW)." Leo F. Hemp opened his museum about 1944. In 1974, he sold his collection to Bonanzaville USA, a pioneer village and museum in Fargo, North Dakota, operated by the Cass County Historical Society. Hemp died in 1979.

The text on the back of this postcard reads, "Codey's Wonder House Museum. Four miles So. on Hwy. #63. On the east side of the highway. Admission 25 cents. Life-time Hobbies of Roy Kothenbeutel. Wood Carvings–Clocks–Operating Mechanical Marvels. The exhibits have taken Blue Ribbon and Sweepstake awards at Minnesota State Fairs. Also Gifts–Dolls–Souvenirs." The museum building was built about 1960 and the museum existed during most of the 1960s. The building was demolished in 2003 as part of the Broadway South commercial development. It was located at 4800 Broadway South where the Forty-eighth Street overpass was constructed. Roy Kothenbeutel started a company called Retail Delivery in 1936. In 1952, he purchased Rochester City Delivery, which was founded in 1915, from Erwin Stoppel and merged his business into it. When Kothenbeutel retired in 1962, his son Luverne (nicknamed "Codey") purchased the business and has owned and operated it since. The nickname Codey is derived from Kothenbeutel. Codey was also the Olmsted County Fair board president for 25 years until he retired in 2007. Rochester City Delivery is now often referred to merely as RCD.

ACROSS AMERICA, PEOPLE ARE DISCOVERING
SOMETHING WONDERFUL. *THEIR HERITAGE.*

Arcadia Publishing is the leading local history publisher in the United States. With more than 3,000 titles in print and hundreds of new titles released every year, Arcadia has extensive specialized experience chronicling the history of communities and celebrating America's hidden stories, bringing to life the people, places, and events from the past. To discover the history of other communities across the nation, please visit:

www.arcadiapublishing.com

Customized search tools allow you to find regional history books about the town where you grew up, the cities where your friends and family live, the town where your parents met, or even that retirement spot you've been dreaming about.